Faith in the Fashion District

Faith in the Fashion District

Beverly Varnado

10-13-18

To my dear friend, Ann, a woman of faith!

Blessings,

CrossLink Publishing
Castle Rock, CO

Beverly Varnado

CrossLink Publishing
558 E. Castle Pines Pkwy, Ste B4117
Castle Rock, CO 80108
www.crosslinkpublishing.com

Faith in the Fashion District/Varnado —1st ed.

ISBN 978-1-63357-120-4

Library of Congress Control Number: 2017955594

First edition: 10 9 8 7 6 5 4 3 2 1

Quotes by Oswald Chambers used by kind permission of Oswald Chambers Publications Association.

Cover Fashion Illustration used courtesy of the artist, Beth Stephens.

Author Photo, Kristin Benton Photography.

As a Ford model during the 1980's, the New York fashion world was my world. Beverly's encouraging stories of how God moved in that sphere help us realize that no matter where we are—even on Seventh Avenue—God wants to use us for His glory.

Nancy Stafford, Actress ("Matlock"), Speaker, and Author of *Beauty by the Book: Seeing Yourself as God Sees You* and *The Wonder of His Love: A Journey into the Heart of God*

Varnado's memoir held me captive in sweet surrender from the deep, gentle South to New York City's fast-paced Fashion Capital of the World, Seventh Avenue. Inspiring. Funny.

Marion Bond West
Author and Contributing Editor, Guideposts

Varnado's *Faith in the Fashion District* is relatable, heartwarming, and refreshing. It details the struggle between a fast-paced career in worldly settings and an internal faith that grows stronger with each opposition encountered. I am intrigued by how Varnado uses simple life moments to show breakthroughs in her faith at many different stages in her career. You'll feel at home with the author's experiences because she brings Christ to the center of every occurrence, making Him sovereign in her outcomes and decisions.

Erica Lane
Recording Artist on Billboard Top 40 Indicator and Billboard AC Indicator charts
Songwriter featured in box office movie Left Behind
Former Miss Houston and Top Ten US Miss World

Beverly's insights into the fashion world ring true for me. She movingly conveys how she was able to serve God as an ambas-

sador and spread His word and His love in the fashion business—whether in a department store, at the Atlanta Apparel Mart, or on Seventh Avenue. Christians who often feel alienated in the business world can take comfort and inspiration from this book, which is both an engaging memoir and a heartfelt testimony.

Kimberly Crosland Vaughn
Runway and Print Model
Pageant Coach
Former House Model, Saks Fifth Avenue
Mrs. Georgia America, Mrs. Georgia International, Ms. American Woman Over 30
National Spokesperson, Sjögren's Syndrome Foundation

For my firstborn, Aaron. You are a blessing beyond imagination. I know God uses your sense of honor, deep insights, and compassionate heart for much good. So proud to be your mom. I love you always.

For my daughter, Bethany. You are an amazing gift. Your boundless creativity together with your sense of justice and tender heart are mighty in the hands of God. So thankful to be your mom. I love you much.

For Mari, who I sometimes forget I didn't physically deliver. You are a continuing source of joy. I'm grateful for your desire to serve and help others and the work you are doing that brings healing to so many. I love you.

For Walker and Sara Alden, with love, for being the two best grandchildren ever. We may not be related by blood, but we are related by heart.

For Brent, who has been ever supportive with technology assistance. You're a fine son-in-law, and I knew you were the one from the start. With love and gratitude.

Contents

Acknowledgements

Heartfelt thanks. . .

*To my husband and dear companion Jerry, for being my best
cheerleader in my writing endeavors. I love you more. To my
dear family, Aaron, Bethany, Mari, Brent, Walker and Sara
Alden. To my sister, my sweet encourager, Tammy, Foy, and
Christopher.*

To Marni and Mandy.

To my mother, who sees from heaven.

*To my many colleagues in the fashion industry with whom
I shared life for over ten years. You are too many to list,
but I hope your memories are as fond as mine. Those were
wonderful days.*

*To my spiritual mentors, Dr. Warren and Jane Lathem, Rev.
Grady and Doris Wigley, Dr. Gary and Diane Whetsone, Rev.
Walton and Martha McNeal.*

*To the people at Rays Church, who continue to support my
writing projects. You are dear.*

To my loyal and faithful readers at One Ringing Bell.

To the precious women in my writing group—you are the best.

To the men of the YMCA Bible Study — thank you for the many prayer cards. Your prayers have helped this project see fruition.

To Cindy Sproles for your invaluable critique of the manuscript and your encouraging words.

To Torry Martin and Doug Peterson whose book, Of Moose and Men, *inspired this one. To Doug, for your helpful writing advice, and to Torry, for your comedic wit, which helped heal my grieving heart.*

Remembering my beloved dad, Steve Chitwood, (1928–2015).

A Bow Tie, Rolled Eyes, and Welcome to New York

"Which floor?" The big-city elevator operator eyed me with suspicion. Perhaps he thought the question might be too much for me to handle.

"Twuhnty-wuhn," I drawled, newly aware that my vowel pronunciation automatically marked me as Southern. My attire didn't help my sophistication level, either.

In the early eighties, preppy ruled in my part of the South—especially so at the large department store chain I'll call Franklin's, for which I was a junior sportswear and dress buyer. Why, if it didn't button down, run plaid, or have brass buttons, we didn't care for it. In fact, the company was about to take a long walk with a certain designer who loved to put little ponies on much of what he made.

On my first trip to New York City, I missed the memo that said everyone in the metropolis would be dressed in black. It seemed like they were going to a wake. Not only that, but they dressed that way—Every. Single. Day.

I, on the other hand, wore a blue oxford cloth dress and navy blazer accessorized with a navy and green bow tie, which made me look as if I were about to take my eleventh-grade English exam. I might as well have been holding a sign that read, "Hick from the sticks. Please rob me."

Marked.

In my defense, *Women's Wear Daily* had recently run a front-page spread entitled, "Preppy," but I guess those who actually worked on Seventh Avenue didn't drink the water—they only sold it.

I stepped in the elevator, turning my head to avoid a potential eye roll from the operator. The doors closed, and we lurched upward. I would never get used to those manually operated elevators, which often overshot or undershot the floor. When I closed my eyes to try to sleep after a day ascending and descending on Seventh Avenue and Broadway, I would still be up and down, up and down in my head.

Somehow, my stomach and my body arrived together on the twenty-first floor. I stumbled out of the elevator and headed for the showroom. I didn't have an appointment but had been told I didn't need one with this vendor. I took a deep breath, collected myself, and opened the door.

I hadn't said a word before a sales representative greeted me. "So, you're from Franklin's."

Marked. I guess my bow tie had spoken for me. Evidently, we Franklin's people were the only ones in the market waving the preppy banner.

I was less self-aware of another distinctive imprint I bore. One night two months earlier, I had surrendered my life to God after a few years of wandering in a far country of rebellion. The altar had been the side of my bathtub. I knelt, bowed my head, and let the water from the overhead shower wash over me while God also washed away the sin that had so firmly gripped me. I hadn't realized it at the time, but right then, God placed His identifying seal on me.

I didn't expect Him to ask me to do something I had never done before—walk with spiritual integrity in a place that did not have a Southern Bible Belt culture of Christianity and among people who might think me a little (or a lot) strange. At best, some expressed apathy, at worst, antagonism.

On a Sunday in October of 1980, I had taken my seat on a Delta DC-9 headed for LaGuardia for that first journey to the markets of Seventh Avenue.

I felt small and scared, a young buyer from Georgia only one generation away from people who scraped out their livelihood from someone else's red clay fields and paid for the privilege of doing so through a portion of corn and other crops.

"Tell me about my grandfather," I once asked my dad.

He summed up his own father's life in three words: "He worked hard."

Indeed, he must have to bring a family of seven through the peak of the Great Depression by the toil of his hands. The same circumstances applied to my mother's family, who told stories of mule-drawn wagons and crops stolen from fields by those hungrier than them.

How unlikely that their grandchild would now be headed to one of the most sophisticated cities in the world. Why, my grandparents didn't even have indoor plumbing.

I was told I had every girl's dream job.

How I landed it I don't know, other than sheer persistence. I had an art degree coupled with education and business minors, but I also had a good bit of retail experience during college. I guess the combination sufficed, because at the time, the job market was tough.

I didn't care why they hired me. I'd done the starving artist thing—not for me.

This job had the potential to completely alter one's priorities. It had altered mine. During my first two years with Franklin's, it seemed the world might shift off its axis if I chose the wrong style or color. I found myself devouring resource lists and fashion magazines like a woman possessed, but after my faith experience, I no longer saw what I did as my raison d'être, my reason for being. God had become that. This affected every facet of my life, including my work.

I honestly did not know how I would live out my faith while working in the fashion business—it seemed impossible.

Could God use me in this industry?

I hoped and prayed He could.

Getting Grabbed. . .and Saying Grace

I navigated past the man in a raggedy trench coat standing on a corner in Times Square and only made eye contact for a moment. His expression seemed odd—his eyes darting among the crowd.

I pressed ahead through a throng of people, but the next thing I knew, arms tightened around my waist pulling me backward. My mind whirled trying to make sense of the situation. Was someone trying to grab my purse, my briefcase or. . .me? My chest pulsed as I fought back the rising panic.

* * *

Shortly after I arrived in the city, my colleague, veteran buyer Jean, had said, "You need to watch where you're going, otherwise you'll fall into a manhole, get hit by a cab or something."

I couldn't help it. I'd lived in Atlanta a few years as a child and had recently made several trips to the regional Apparel Mart there. Yet, nothing prepared me for the sensory overload of New York City—street carts smelling of burnt pretzels, steaming subway grates, incessant horn honking, yelling cab drivers, gleaming high rises, garish signs, and every other face reflecting an international culture.

"I just want to see everything." I found myself standing in the street twirling Mary Tyler Moore–style. Mary had always inspired me, and if I'd had a beret, I would have definitely thrown

it. But this was not Minneapolis. It didn't take long to arrive at that conclusion.

I had great admiration for Jean—smart, patient, and. . .tiny. I measured five feet nine inches. I'm not sure she touched the five-foot mark. I wore heels. She wore flats. There was probably a good foot of height difference between us as we traversed those congested streets.

She'd given me strict instructions: One, walk fast. Two, don't make eye contact. Three, keep your purse in front of you. Four, hold tightly to your briefcase.

A word about that briefcase: As a buyer, I'd learned it was better to invest in one good piece for the long term than in many inexpensive pieces. My leather case had been a sizable investment on my meager buyer salary. Made of smooth burgundy leather, it had two zipper pockets inside and brass fittings on the handles. I loved it and hoped it would prove long-lasting (which in fact it did—the entire time I worked for Franklin's).

Jean and I, along with several buyers from our regional group of stores, chose to stay at the Sheraton Centre on Fifty-Second Street. We had to walk to our corporate buying offices on Thirty-Forth. We rarely took a cab, so this meant hoofing it twenty blocks one way. It wasn't uncommon to walk a hundred blocks a day in those heels I always wore. After about ten years, I thought my feet would be permanently set like those of my childhood Barbie dolls. Wearing tennis shoes to the garment district didn't seem like an option. I wouldn't be caught in them inside the buildings, and under no circumstances would I lug tennis shoes around all day in my briefcase.

We passed through Times Square to reach the garment district, still a long way from the Disneyfication it would see in future years. Strip clubs and sordid little shops selling I don't know what lined the streets we traversed. I tried not to stare, but it's likely that if I'd been a cartoon character, my eyes would have literally popped out of my head.

Jean aimed to hurry me along to our destination without much success. I continued to amble the streets, appearing as if I'd just gotten off the boat.

In retrospect, I know Jean felt responsible for me. One of her particular concerns was that in my enchantment with the city, a rolling rack would clip me when I crossed the street. At that time, much of the apparel we bought was made right there in the city. (Sadly, much is outsourced today.) With dress vendors especially, so many of the FOB (freight on board) originations on my purchase orders read New York City. In order to move it between factory, warehouse, and showroom, rather than load it into a truck for such short distances, workers rolled racks down the street.

"You know," Jean had said, "I once knew a man who didn't pay attention and had his Achilles tendon clipped by a rack. Be careful."

Jean's concern for me proved justified. Well, not with the rolling racks, but as we hoofed the twenty blocks to the fashion district, I violated rule number two. I made eye contact with that man on the street corner.

Fortunately, I had taken to heart rule number four. The investment in that leather briefcase was about to pay off. After he grabbed me, I broke free and whammed him with that thing—hard, because it contained two full order pads and my buying plan notebook. It shocked him enough that he stumbled back, and Jean and I ran ahead.

Do I need to say here that it scared little Jean right out of her tiny flat shoes? It didn't do me any good, either.

She glared at me. Somehow, she knew I'd done something to make myself a target.

"What?" I said.

I tried to ignore her steely gaze as I gripped my trusty briefcase with shaking hands and trekked on down the street.

No, Mary, we were definitely not in Minneapolis.

* * *

Franklin's was a large department store chain—well, not a chain, but it would require a separate book to explain its complicated structure. At the time, it ranked as the largest privately owned corporation in the world with the majority stockholders being mostly descendants of the man who founded the company. Family involvement made for plenty of intrigue and legendary stories.

Though we had buyers at the corporate and regional levels, local buyers made the decision for the bulk of what came into our stores. That was my job. My store was located in a large mall in a university town. I also occasionally participated in making decisions about corporate buys done by an association of store buyers.

This successful company would soon celebrate its one hundredth anniversary, and one of the main ingredients behind this triumph was having a designated buyer in every store to accommodate the tastes of local customers. Corporate buyers handled private label transactions and put together planned purchase distributions, which might compose a small percentage of our total purchase, but ultimately it rested on store buyers to accept or reject them. One example why this formula worked: My store sold an inordinate amount of the university's red and black colors. Having a local buyer to accommodate that nuance proved quite profitable.

As you might guess, customer service was our thing, and we went to great lengths to make sure every purchase left the customer smiling. We operated more from a boutique concept and took our cue from places like the legendary Rich's department stores in Atlanta and Nordstrom.

At our company buying offices in New York, we usually worked with corporate buyers for individual attention and a preview of the market. Then we hit the streets. We sometimes had

appointments with vendors; other times we'd take a chance, stop in a showroom unannounced, and occasionally find new resources that way.

I deciphered what had seemed a maze at first—more upscale resources were housed on Seventh Avenue and most of the moderate-priced sportswear and dresses were in 1400, 1407, and 1411 Broadway.

After a morning in the market, my associates and I converged at Harry's Deli. It seemed the whole fashion district did the same thing. Sales reps, buyers, merchandise managers, personnel from buying offices—all of them headed for the best deli anywhere. It was so popular that it had to annex spaces in adjacent buildings and still always seemed jammed.

On my first day in the city at lunch, as several in our group gathered to eat, I knew I faced a dilemma. I had told God I would never be ashamed of Him, and for me that meant saying grace no matter where or in whose company I found myself. No judgment if that's not what anyone else did, but I absolutely had to. It meant being willing to be seen as a woman of God.

As we received our food at the table, I didn't make a big deal. I glanced around at others who discussed their purchasing successes and failures of the morning, and then bowed my head and thanked God silently for the food.

When I looked up, a couple of people eyeballed me. This was supposed to be between God and me—not about drawing attention to myself. But in the end, it felt as if I were doing exactly that.

"So what did you think of that new dress line we saw today?" I asked, squirming a bit and taking a sip of lukewarm unsweetened tea—my beloved Southern sweet tea being an oddity in the North.

At night, as we assembled at a restaurant, I'd face the same situation again. I'd bow my head, lift it, and someone might be directing a raised eyebrow at me.

There may have been more than one reason for this. Shock, perhaps. Some of the folks I traveled with had previously witnessed behavior from me that would have seemed mighty inconsistent with praying before a meal. They may have wondered where the old me had gone.

God had led me to simply let my actions speak for themselves for a season rather than sound off about what had happened to me spiritually. I wanted to tell them the old me had been washed down the drain one evening, but God asked me to walk it out instead. I found it a difficult challenge.

A few may even have been offended by my actions.

Either way, the effect on me was that I felt alone.

I later understood that those times of depending only on God helped forge my faith in the early years of walking with Him. Being a Christian was not what the cool kids were doing, but it was what I was doing.

Saying grace in public was a small beginning that set me on the path toward learning to live without regard for what others thought and recognizing only God's opinion matters.

The book of Zechariah asks, "Does anyone dare despise this day of small beginnings?" (Zechariah 4:10 MSG). Praying in front of my colleagues might not seem like such a big deal to some. But I'm telling you, for me it was a big deal. In the past, I had been more concerned about the color of my nails than the state of my soul. Altering my perspective and external behavior signified the altering of my heart. It meant being willing to risk rejection or ridicule because I had determined to follow God in every facet of my life—the beginning of a different kind of life.

Seeking to live Christian faith in the midst of apathy or antagonism takes a firm resolve to persevere and not be swayed by others' opinions, especially in our cultural climate today. I can see now that my small beginning was not so small after all.

LA: City of Angels?

Company executives in our regional group of stores thought it would be a good idea to send several of our buyers to Los Angeles to check the market there. They chose a contingency of four buyers from our largest stores and for some reason included me in the group. Franklin's was expanding into newer and larger markets and needed to make sure we covered our bases to stay competitive.

Fine with me. I'd never been to the West Coast. In the end, we'd find the market too forward for us. For example, California vendors were shipping halter tops in February. Meanwhile, back home in Georgia, we were often getting our coldest weather of the year. Why, it might even dip down into the thirties. The West Coast market would have probably worked well for Florida stores, but not for us. But hey, we didn't know that yet. So off we went.

When I look back at my journals from that time, I start to see notations in early October about that mid-month trip. Prayers for the long four-hour plane ride. On the one hand it seemed an exciting opportunity; on the other hand, I dreaded it.

My fear of flying started a few years prior to the LA trip, on a flight from West Palm Beach back to my home in Georgia. The flight was so turbulent that others on the plane used their barf bags. I'm pretty sure I had an anxiety attack.

I didn't fly again after that until my first trip to New York as a buyer. Thankfully, the flights there and back had been uneventful.

As I considered the flight to LA, I knew I'd be in the air for twice as long as the New York trip. I needed to buck up. Glad

God and I had gotten on good terms; I definitely planned to pray without ceasing.

I don't actually remember much about my first cross-country flight. I do have a photo of the Rocky Mountains taken from the airplane cabin. My first sighting. Beyond my imagining, less than a year later, I would return to those mountains in another unexpected twist, but I'm getting ahead of myself.

We arrived on a Saturday and had reservations for the week at the Hyatt Regency, an upscale hotel in downtown Los Angeles at the time. I had to hand it to Franklin's. The travel agency they used always made sure we had wonderful accommodations. A revolving restaurant crowned the hotel, much like the one I had long admired at the Hyatt Regency in downtown Atlanta. That first night, we spun in a circle while eating dinner and surveying the city. I probably ordered chicken. Jean, whose taste leaned toward the gourmet, often turned her nose up at my limited menu choices. I had what a highly cultured friend of mine would call, "an uneducated palate." My enjoyment of new experiences did not extend to culinary adventures. I liked to play it safe in that arena, but even while eating chicken, yet again, that night stacked up as one of those amazing experiences that I, a gal who had recently emerged from the Blue Ridge foothills, almost had to pinch myself to believe.

On Sunday, we rented a car and did every touristy thing we could find. We sailed Rodeo Drive, gawked at movie star houses, toured Universal's back lot, and jammed our feet in the concrete impressions at Grauman's Chinese Theatre. I took a photo of Clark Gable's feet to show my mom, one of his biggest fans. Later we drove out to the pier in Santa Monica, and I had my first look at the Pacific Ocean. In a photo of the other three buyers and me against a backdrop of breaking waves, I tower over Jean while wearing heels and carrying my briefcase as if it were another appendage. (Seriously, no wonder my right shoulder is so much

lower than my left today. Dr. Scholl's and I are well acquainted. What was I thinking?)

On Monday, we hit the apparel market. LA's legendary smog hung over the city like a thick shroud, so we decided that instead of walking to the market we'd take a cab. (There were some among us who had breathing issues.)

As we progressed from showroom to showroom, we quickly started to see that the shipping dates were not going to work. Yet we were paid according to our profitability, so we intended for this to be more than just a research trip. We wanted to salvage the journey and make it worthwhile.

That night, we gathered for dinner to discuss what we'd found and what our strategy might be to deal with the challenges. Before we ate, I did the usual and bowed my head silently to pray, and as usual, I could feel the eyes of others boring into me—alone again in my faith. I always felt like the last Christian on earth. I didn't think I would ever get used to sticking out like a strange anomaly.

We lingered awhile over dinner discussing our buying options before getting ready to head back to our rooms. Before we left, a man seated near us came and stood beside our table. I looked up. What did he want? I thought, Oh please tell me he doesn't intend to hit on us. Not interested.

Instead, he said, "Few have the courage to say grace in public. Don't ever change."

Courage? Me?

I scanned the seats around me in the restaurant to see if he might be speaking to someone else, but when I turned back to him—poof—he had vanished.

I sat back in my chair trying to process what had just happened. I also wondered what the others at the table might think of the encounter. No one commented.

I noted on the Hyatt Regency letterhead where I was recording my thoughts that week how shocked I was at his words. I had

struggled to get used to the eyeballs on me at my own table; I never thought about anyone at another table noticing.

Through the years, I've wondered who that man might have been. Maybe an angel? After all, we were in the city of angels. A Christian writer or speaker? Perhaps. Or maybe a sales rep, on the road like me, who wanted to extend a bit of encouragement, feeling a bit alone in his faith, too.

Repeatedly in my journals I wrote that I wanted to be just "one person." I didn't want to be one person at work, another at home, and another at church. That had been the kind of hypocritical life I'd lived earlier: hiding my sin while putting on a superficial front. I wanted the threads of my life to come together.

A few weeks prior to the LA trip, I had written this prayer: "Father, I want to give myself wholly and completely that others might know You. May I see Your will for my life as my eternal happiness. May I be transformed so that others may see You in me."

This would take some doing. To be rid of the duplicitous life I had led in the past, I needed God to do what only He could do. Oh, I could read my Bible, pray, and attend church, but I needed that ongoing deep heart change that would help me consistently choose God's will over my own and help me overcome my fear of what others thought of me. It was time to stop trying to fit in and instead be the woman God called me to be whether or not I blended into the landscape—a battle that would take courage and perseverance.

"Don't ever change," the man had said. His words have haunted me even in recent years when I've been at social gatherings where public prayer certainly isn't the norm. For a lifetime, I've never forgotten the sales rep, or angel, or whoever he was who approached me and how, in a faraway city, he made me feel not alone in my walk with God after all. His encouragement gave me courage to stay on course, then and now.

One evening later in the week, the other buyers and I went down to Chinatown. I bought a little teak jewelry box with a jade inlay and gave it to my mother. On her death many years later, it came back to me and now sits in my daughter's bedroom holding her treasures. The treasure it most brings to mind, though, is echoed in words found in Joshua. He faced the daunting task of leading the Israelite tribes into Canaan after the death of his mentor, Moses. God speaks an exhortation to him in chapter one, verse nine: "Have I not commanded you? Be strong and courageous. Do not be afraid; do not be discouraged, for the Lord your God will be with you wherever you go."

"Wherever you go." God promised that he'd be with Joshua, and He extends the same promise to us. God is present to give us courage to persevere for Him.

Maybe sometimes he even sends an angel to help us along.

A First Class Surprise

I looked up from my seat in coach and couldn't believe who emerged from first class.

Seriously?

I nudged my colleague, Valerie, sitting next to me on the plane. "Is that who I think it is?"

She gazed up from the book she read, and her face reflected the same shock I felt. She nodded, "It is."

A few months after the L.A. trip, Jean, a widow, had remarried and moved to Florida. On her departure, she gave me a tiny pewter figurine of a sea lion—a reminder of one late afternoon visit we made to the Central Park Zoo where we lingered a long time taking in the sea lions' playful antics. It became one of our favorite shared memories of the city.

I would miss her.

Her former job buying misses moderate and better sportswear, as well as dresses came to me as a promotion. I had been buying juniors and supervising cosmetics purchasing. The two areas were so different and had grown so much in volume that company executives decided to split that position and bring in two people to replace me. My next buying trip would be with the new junior buyer, Valerie.

Before I felt I even had time to get my bearings, Jean's departure had put me in a senior buying position. I would be the tour guide on our travels just as Jean had been to me. A little scary. Jean's expertise had been invaluable. I could not have hand selected a mentor from whom I could have learned more. With only two years with the company, I had doubts about whether

I had enough experience, and I in no way compared myself to her, but I guess my bosses had more confidence in me than I did because there I was.

Valerie had no sooner moved to our store than she accepted her boyfriend's proposal. They set the date for six months out, and at that point, she would be moving again. So her first buying trip to New York would most likely be her last, at least with me.

More and more I considered the mission field God had assigned me. I prayed for opportunities to share, to connect, to win others for the Lord. I often couldn't do this in an open way, but I prayed for windows.

I did not know where Valerie stood with the Lord, but I hoped the trip would be a special one for her. As I usually did, I prayed over every aspect, including the flight itself—the pilot, the attendants, the mechanical functioning of the plane, the air traffic controllers, and the people with whom we would be traveling.

Again, before any flight, I usually experienced anxiety, but I had affirmed in my journal as I prepared for the trip that praise drives fear away. The Sunday morning before my flight, I played the piano for the elderly in a nursing home and went on to church where I helped with the music for children's church. All of that music and praise helped lift my heart as I caught the shuttle to the Atlanta airport.

On a beautiful clear November afternoon, our plane taxied down an Atlanta runway and took to the skies, headed for Manhattan.

What happened next clearly confirmed the words in Ephesians 3:20—that God is able to do "exceedingly abundantly above all that we ask or think" (KJV). I would never have thought to pray specifically for it, but my prayer for the people on the flight took on huge dimensions.

It would be an understatement to say Valerie and her fiancé were politically oriented. Politics almost eclipsed everything in their life. At the time, her soon-to-be husband worked on a

congressional member's political campaign, but I imagined that he might run for office himself in the future. And so, for a while, that's what Valerie and I discussed before we both began reading our books.

I had just looked up a moment when I saw the last person I ever expected to be with on a plane and nudged Valerie.

Another one of those somebody-pinch-me moments.

"Did you see him when we boarded?" I asked.

Valerie shook her head.

I closed my book. "He must have come in late to first class."

The thirty-ninth president of the United States, Jimmy Carter, smiled his Plains, Georgia, smile while shaking the hand of everyone on that 727. He had only lost his reelection campaign two years prior to Ronald Reagan.

Valerie and I looked at each other incredulously.

I can't even remember whether Valerie pitched her tent in the same political arena as he did. I only remembered it didn't seem to matter.

Flanked by the Secret Service, he moved closer to us. I whispered to Valerie, "I prayed about this. I think God did this for you." I believed it. If anything would have made the trip special for her, it would have been meeting a political figure like President Carter. I didn't think I'd ever forget the experience either. I debated inside myself what brilliant thing I might say to him when he shook my hand, but "So nice to meet you," seemed all I could manage. He shook my hand and then grasped Valerie's.

Neither of us returned to our books the rest of the trip. We just sat there slack-jawed trying to process what had happened.

But, God wasn't finished yet.

Val only saw her mom and dad once a year because they lived in California. Her sister had just moved to New Jersey, and her dad was visiting her. I still don't know how, but her dad and sister managed to meet us at LaGuardia in a very narrow window of time before her dad's 7:00 flight from JFK back to California.

A sweet reunion.

That evening after arriving at my hotel, I reflected on a verse the Lord had given me early that morning: "Sing to God, sing in praise of his name, extol him who rides on the clouds; rejoice before him—his name is the Lord" (Psalm 68:4).

I had begun the morning with praise, and if I ever sensed God riding on the clouds with me, it had been during that flight into New York City. I didn't even know former presidents flew commercial. I don't know what I thought they did, maybe private charters, but it seemed God Himself had chartered that trip for us. Hanging up there at 35,000 feet, God spun an experience we would remember for a lifetime.

Also, Valerie had that glorious meeting with her dad and sister for a few moments.

Only in my life for a few months after that trip, Valerie did move on after she got married. I never saw her again. I have no idea where she is today, but I wonder if she, too, looks back on that day and sees the hand of God as clearly as I do.

When we are diligent to pray, God responds to those prayers in ways we may not anticipate. Surprising ways. Beyond-imagining ways.

Certainly, the Bible is full of such occurrences.

David, who wrote about God riding on the clouds in Psalm 68, had begun life as a shepherd boy, perhaps never imagining his life would encompass more than those Judean hills. God had bigger plans, and David's faithfulness in watching over a few sheep was only the small beginning of his future story—becoming a kind of president himself: king of all Israel.

Of course, the rest of the buying trip was uneventful compared to the experience of meeting a former president.

But doing so forged in me the significance of prayer and the exceeding and abundant power of our awesome God.

Big Shoulders, Big Hair, and a Big Discovery

Five words about fashion in the eighties: big shoulder pads, big hair.

If you didn't live through those years, find a rerun of the television show Designing Women[1] and watch it. The characters Dixie Carter, Delta Burke, Jean Smart, and Annie Potts brought to life epitomized fashion in the eighties.

In fact, if Mary Tyler Moore had been my paragon of fashion in the seventies, Dixie Carter in her role as Julia Sugarbaker personified my idea of what style should be in the decade that followed.

On more than one occasion, I was accused of having a few of the same qualities as Carter's character. Whether meant as a compliment or not, I took it as one. No, I didn't always embrace her politics or her standing on social issues, but I admired the character's determination and forthrightness.

Back to those shoulder pads.

As the eighties wore on, I left the preppy camp behind and segued into a more on-trend look, which was almost inevitable because of all the travel I did to New York. I grew tired of standing out in the crowd, at least in a fashion sense. I wanted to save my energy for being set apart for matters of greater importance.

The phrase "power suit" originated in the eighties. We women were using those symbolic shoulder pads to try and shatter the glass ceiling we were experiencing in the business world when it came to advancement. I would do it wearing a blue wool crepe

suit, the shoulder pads of which had to at least equal or surpass the ones my husband wore when he played college football.

The last time shoulder pads in women's fashions had been that big was during the forties when men shipped off to war and women assumed the role of running the country. Some think the shoulder pads were a nod to the epaulette-adorned uniforms military personnel wore.

When you purchase a clothing item, don't kid yourself that you're the lone soul who selected it. Several someones have picked that garment out for you. The process often starts on the European runways, and then the styles and colors filter down to the places most of us shop. Many influences besides the designers themselves contribute to this process.

The dress Lady Diana Spencer, the late Princess of Wales, wore at her wedding in 1981[2] hugely affected the look in the eighties. Those billowing sleeves shaped bridal design and women's fashion in general for many years. My sister, Tammy, married in the eighties, and the mauve maid of honor dress I wore in her wedding had a version of those same sleeves.

Additionally, Nancy Reagan, like Jackie Kennedy before her, sent out ripples through the fashion world. As a child, I remember a pillbox hat my mother wore to church very much like the ones Jackie wore. Kennedy's style influence was so far reaching that, at around eight years old, I even received a tea set for Christmas emulating the one she used to host White House dinners. We still wear today a style of sandals[3] she made famous. And where would Lily Pulitzer be without her?[4] The shot of Kennedy wearing a Pulitzer design in *Life Magazine* rocketed the brand's success.

Nancy Reagan, an actress in the forties and fifties, brought her sense of Hollywood style to the White House—a look that would be characterized as both "simple and elegant."[5] Her love of Chanel was emulated in women's fashion with brass-button suits

and pearl and chain necklaces. She often wore the big shoulder pads, too.

Though Franklin's still may have been firmly ensconced in their preppy ways, we sought to make a strong statement in the fashion areas of our stores. Therefore, our merchandise mix included the most forward silhouettes we could find in the market. Those styles might not have been our best sellers, but they were what we would call "eye candy" today.

And the big hair? Apt to have big hair whether it was in style or not, my naturally curly locks usually had a mind of their own, especially on rainy days. My hairstyle had morphed from the Farrah Fawcett look of the seventies to the giant hair of the eighties. Lots of hair spray, my friends, lots of hairspray.

I have a buyer friend who says she would never again be able to make her hair look the way it did in the eighties.

Nor would she probably want to.

In my attic, I store a few pieces of clothing I saved from that time, and whenever my vintage-loving daughter is scouting for garments new but old, she scavenges through my collection. She last descended from her fashion expedition with a Fortuny-inspired pleated dress. "That's the dress I wore on my first date with your dad," I told her. That information seemed to confirm she had plucked a treasure from her search. She carted it back with her to the urban Atlanta neighborhood where she lives. She'll look very hip wearing the dress. On the other hand, if I wore it, I would just look like I had on old clothes from my attic.

Another item in the attic reminds me of searching through racks of dresses in the back room of one particular Seventh Avenue designer. The vendor had offered to sell me a design for my personal use at wholesale, and there were so many lovely choices. I turned to a friend who was with me for advice. "I don't know which one to buy."

She smiled and plucked a dress from the rod. "The red one of course," she said, holding up a Crepe de Chine dress with the

requisite large shoulder pads. I had to wonder if the "Reagan red" that the president's wife made famous had influenced the color. I still have that dress, a tribute to Nancy.

Dresses were what I most enjoyed purchasing for our store, and for myself, too. The silhouettes, the fabrics, the kaleidoscope of colors in the eighties all made for such fun. I always found it hard to watch the budget with a dress vendor, because silk was abundant and no other fabric took color like silk. Nothing felt like silk.

And the linen skirts and blouses—an ironing nightmare, but wow, did I love them. In my off hours, I had a whole collection of long denim skirts by that designer who put ponies on everything. I'd throw on a knit top or sweater and a lightweight wool or silk scarf with them, and that was pretty much my weekend uniform for years. It's how I took on Washington DC one fall when a friend and I decided to spend a little of our own money and add a side trip to Washington on our way to New York. I have a picture of me on the National Mall in a version of that outfit near the National Gallery of Art Sculpture Garden Pool (Years later, my children would be evicted for wading in that pool. Oh wait, that's another story.)

That trip to DC is also when I further added to the lowering of my right shoulder by lugging a suitcase for what seemed like miles. Somehow we'd missed the news that Union Station was under renovation, and because of it, there were detours around the usual routes to the taxi stands. We were forced to drag our luggage an extraordinarily long way. My colleague had made the smart decision to buy a newfangled suitcase with wheels. I on the other hand clung to a piece of leather Hartmann luggage that was right up there in my affections with the aforementioned briefcase. After that trip, wheels all the way for me. Well, almost. I never could completely let go of that leather suitcase.

Up there in the attic, I also hold onto a couple of pairs of short loose pants we called "gauchos." I bought them at a sample sale

we stumbled upon on Seventh Avenue. I loved those pants. I have a photo of me wearing them while touring England. They are actually pieces I'd wear today, if I could. I made a recent purchase that is a similar style. The couple of inches I've gained in the waist after two babies prohibit fitting into my old ones, though. Strangely, I don't weigh that much more, but things are definitely rearranged.

Being able to pick up a few items here and there in the market helped stretch my budget and ensured my wardrobe would stay current. I needed to dress for the job I had but also for any potential opportunities that might present themselves.

When I first started with Franklin's, the stores with budget or discount departments offered stretchy polyester women's slacks with elastic waists as a doorbuster item. I would look at those things and wonder how any woman could allow those fashion nightmares on her body. Stretch pants, yuk.

Well friends, today stretch is in, and my affinity for it has grown exponentially. I am right now wearing a pair of black spandex-blend pants similar to the ones we used to offer. A little different fabric, but the same comfort level. I love them.

Several years after my time with Franklin's, my husband and I took our little son, Aaron, to the Georgia coast for a vacation. While standing on the shore for the first time, with waves moving in and out, my son gazed up at my husband and asked, "Dad, is this the sinking sand?"

Puzzled, my husband wondered where he got the phrase. Then he remembered the lines of a hymn, "On Christ the solid rock I stand, all other ground is sinking sand." Aaron's feet were going deeper and deeper into the sand as the water swirled around him, and he just knew, in the concrete thinking of a four-year-old, that he'd found the sinking sand from the song he'd heard about in church.

In *The Message* translation of the Bible, Matthew 7:26–27 reads: "But if you just use my words in Bible studies and don't

work them into your life, you are like a stupid carpenter who built his house on the sandy beach. When a storm rolled in and the waves came up, it collapsed like a house of cards."

During my years at Franklin's, I routinely went into fashion houses on Seventh Avenue that seemed to be built on sinking sand—structures built on superficiality and misplaced priorities. I hung out with many who had chosen to take up residence in those houses, which could fall with nothing more than a small puff of wind.

I liked the pretty, pretty clothes, but I didn't want this fickle industry to rule me. I didn't want to be like the stupid carpenter about which Jesus spoke. More than anything, I longed to build my life on the Solid Rock. But how could I do that for the long haul in that environment?

That's when I met a few women between the pages of the Bible who helped me make sense of it all. More about them in the next chapter.

Today, no one is wearing big shoulder pads unless they're trying out for football. It seems comfort is what we're all looking for, but I still sometimes miss those big-shouldered jackets, the power suits, the Nancy Reagan jewelry (although chains are making a bit of a comeback), and those lovely silk dresses.

Ah, well, there are always *Designing Women* reruns. Did I mention how much I love Julia Sugarbaker?

Fashionistas of the Bible

The fashion industry? How spiritual could that be?

Then one evening, I cracked open my Bible, and right there in the book of Acts, I found Lydia. Thought to have been the first Christian convert in Europe, she, my friend, was in the fashion industry—a businessperson. Whether she simply sold purple dye or purple cloth, no one knows for sure, but the fact is, she made her living selling a product related to what people wore. That's what I did. From Lydia's profits, she supported Paul and others who spread the gospel of Jesus Christ.

Acts 16:14 speaks of her heart being opened to the Lord, and that's what I wanted my own heart to be. Open. Ready. I longed for God to use me in whatever way He would, but I felt a bit caged in. A picture of a popular cartoon character at the time, Ziggy, adorned the wall of my office. Round-headed Ziggy stood with his head turned heavenward, and the caption read, "Put me in coach." Often a sales rep or other visitor would comment on the caption. Though the poster didn't mention a verse of Scripture, God, or Jesus, through the years it opened doors for me to share my faith. In many ways, the cartoon itself helped God to "put me in."

I also drew encouragement from the woman in Proverbs 31. A woman after my own heart, *The Message* says she "dresses in colorful linens and silks" (verse 22). With my linen and silk affinities, we would have had a lot in common. "Her clothes are well-made and elegant," the writer of Proverbs continues (verse 25), but known not only for these things, like Lydia, she created fabrics for garments she sold, as well as clothing for her own family.

She prepared family meals, bought and sold land, exercised excellent business acumen, gave generously to the poor and her employees, and consistently exhibited wisdom.

I have to tell you that the Proverbs 31 woman can make me feel a little tired. Definitely an overachiever, and I don't in any way believe God is saying we have to be all these things. Perhaps the Proverbs 31 woman gives us a vision of the various ways we may serve God.

Her example of not being known merely for her appearance but for her Godly actions is echoed in other verses that deal with women's attire, as in 1 Peter 3:3 about our beauty not coming from outward enhancements like "fine clothes." It's important to remember that the Scripture does not say to avoid fine clothes, but rather, don't let your beauty come from those outward appearances.

And that, my friends, is the rub.

Without God at the core of your being, the fashion world can drag you off by the designer scarf around your neck as you clutch the latest style magazine to ride the in-today-out-tomorrow trends ad infinitum.

You're never settled. You're never done. All your perceived beauty rests in how much you adhere to the dictums of people you have never met and maybe wouldn't even like. What's beautiful today will wind up in tomorrow's charity bag.

Early on in my career, I remember stepping out of an elevator with my colleague Jean for an appointment on Seventh Avenue. New in the market, the vendor had just renovated the top floor of the building. The floors were tiled with the most exquisite marble I had ever seen. Jean commented on how the builders of this early twentieth-century building never saw this renovation coming and how the current contractors must have had to shore up even the building's foundation to support the weight of all that marble.

The marble I suppose enhanced the elegance of the vendor's fashion line, the prices of which were without a doubt at the top of what we might consider bringing into our stores.

The external showroom walls were entirely glass. I stepped to the southeast-facing windows, which overlooked the Hudson, and there in the distance the Statue of Liberty lifted her glistening golden torch.

The marble, the beautiful clothes, and even the Statue of Liberty combined to send a message that I had arrived. I felt that designer scarf tightening around my neck.

I'm not sure I can explain it, but simultaneously at that moment I had this profound conviction deep in my heart that my life could not be wrapped around these outward things but absolutely must be centered on God and His desires for my life. Nothing wrong with these things, but if my life became consumed with them, I would err.

The example of biblical fashionistas helped keep me centered, remembering that all of this was ultimately to be used by God for His purposes. I could have been a teacher, and almost went that route. I could have been a concert pianist—my aim when I first went to college. I could have been a nurse. Okay, I couldn't have been, because blood and gore freak me out, but that's what I used to say as a child when folks asked me what I wanted to do when I grew up. In any event, this career is where I landed, so it was up to me to lean hard into His guiding hand and listen for His direction.

The fashionistas in the Bible helped set the parameters for me as I lived out my faith in this business. Another testament to God's always amazing provision.

Turn West, Young Woman

About a year after I first glimpsed the Rocky Mountains through the tiny porthole of a 747 on the buying trip to Los Angeles, I found myself headed west again—this time to get the full sweep of the Rockies while spending a week in Colorado as an adult guest at a Young Life camp. I traveled with a church couple, Jim and Jane, with whom I'd become friends, and Jerry, an attorney I had met at church and had just begun dating a couple of months before. Just to be clear, I'd spend the week bunking with the female counselors, and Jerry would be with the males.

I had met Jerry for the first time only a few months before, when he gave his testimony as the laity speaker in a Sunday morning worship service. Though we hadn't known each other at the time, we had both had life changing surrenders to God within days of each other. It was interesting to compare how God had been leading us since that time.

You may wonder what any of this has to do with "faith in the fashion district." Later, I hope to connect a few dots for you.

It was early evening when we arrived at Silver Cliff. The camp was south of Denver, situated high in the Rockies.

My habit through the years when I couldn't take the time to write out my thoughts has been to make a list of words in my journal that would remind me later what I was thinking.

The list I made that night leaves no room for doubt as to how I felt about my situation after arriving.

I was literally not a happy camper.

Here it is: Four hours of sleep, two hours of jet lag, greasy hair because something is wrong with my hair dryer, pushed to get packed, tough getting a ride at the airport, no accommodations, then wrong ones, loud dinner, moved to still another room, no mountain view. Tired. Really, really tired.

I had just come off a string of long workdays, and I questioned what had motivated me even to make the trip as I stood in a room filled with a dozen sleeping girls all working at the camp that summer. They woke early in the wee hours to prepare breakfast for the campers and went to bed unbelievably early. The entire week, I never met one of them, at least not that I knew of. I may have seen them in the dining hall but couldn't make them out from the dozing lumps I saw every evening when I went to bed. They were always up and gone before me. I suppose I could have gotten up early, too, but my tired, jet-lagged self never managed it.

Why had I come here? As chair of the Young Life Committee in our area, Jerry had asked me to accompany him on this trip to experience the scope of what Young Life does. I slumped down on the miniscule cot I would sleep on that week and prayed. *Lord, I'm exhausted and don't feel I have a thing to contribute, but I'm willing to do whatever you have for me to do.*

It was more of a surrender prayer than anything else, but the sense I got was that God wanted me right there, right then, and I wanted what He wanted. So there. Get over it, Bev.

I fell over on my pillow, closed my eyes and grew still. What was that sound? Gurgling. Wow. A mountain stream so close I could hear it. The soothing stream put me to sleep in no time. When I awoke the next morning, my entire sense of the situation had shifted.

As I walked around the camp, surrounded by the soaring Rockies, a wonder began to envelop me. And those Young Life people were funny; I dissolved in laughter so many times I couldn't count.

Our friend, Skip, the camp director, had also invited a singer-songwriter friend of his to stay the summer at the camp. His friend had been involved in a terrible motorcycle accident in which he was dragged beneath a car and suffered multiple injuries. His survival had been miraculous, but he needed quite a while to recover and would do so at the camp while also providing music in the evenings for the club meetings.

When I first heard him, the beauty of his voice and musical skill floored me. He would recover from his injuries and go on to have a successful career in country music. A very successful career.

His name—John Berry. Later nominated for a Grammy, Berry would go on to have two platinum albums, one gold, and chart nineteen songs, which included one number one and six top ten hits.

For a person who had been involved in music her whole life, this was incredible.

When John Berry sang "Rocky Mountain High," well, I think that did it for all of us.

Because of my acquaintance with Berry, just before his star shot up over Nashville, I asked him to do an in-house event for us at Franklin's. He kindly agreed and we had a wonderful evening because of his musical performance. Much later, he even offered insight on a recording project I made of my own songs.

In just a couple of days I would write, "I'm sitting on the balcony of my cabin looking down the canyon with the sun in my eyes. What joy to be here. I can't think about leaving without tearing up, so I just won't think about it now. The majesty of these mountains is more than I can take in."

The power of what God did in the lives of so many high school people is beyond comprehension. Throughout the week, repeatedly we saw His hand at work changing hearts, giving guidance, and preparing them for the lives God was calling them to lead.

I found it an honor to witness so much good work, but God was also doing a work in my heart.

Near the end of the week, I faced a climb/walk up a 14,000-foot mountain with them. Something in me wanted to weasel out of the expedition. I'm not much on high places, but conviction flooded my soul. I had to go to support all these kids who were making the trip, too.

I remember stopping along the climb and looking up at the winding stream of teenagers moving ahead up the side of the peak. As my eyes slid to the apex, I wondered how I would ever get there. I tried to inhale a deep breath from the thin air.

We at last reached the summit. Skip, who led the group, asked that we pause at the top and wait for everyone to arrive. Then he led us to a point where it seemed the whole mountain range spilled out in front of us.

Now I especially had trouble getting air as I gasped at the beauty.

I have a group picture with that magnificent mountain range in the background, but a photo doesn't do justice to the sense of majesty I experienced.

Even with all the glorious experiences, I still wondered what was going on. Why was I the one looking out over these stunning mountains from one of the highest peaks in the country? What would I take back with me?

At the time, I wrestled with a sense of unworthiness over all that God had done for me, feeling as if I needed to do hard time for the sins I had committed. Well, I did, but I kept having to remember that Jesus had done my hard time for me. God continually met me with this almost incomprehensible grace. A voice inside me said I didn't deserve all this beauty. Grace challenged me to accept it as a gift—a difficult concept for me to grasp.

My last day in Colorado, we went on a wranglers' breakfast via horseback, and in the afternoon we rafted down the Arkansas River. My cup did indeed run over.

My list the evening before we departed was quite different from the one I made when I first arrived: blue spruce, magpies, marmots, mountains touching the sky, chalk cliffs, fire on the mountain, wildflowers, aspens.

Psalm 125:2 reads, "As the mountains surround Jerusalem, so the Lord surrounds his people both now and forevermore." As I left Colorado, I had the sense of being surrounded by the Lord, and that sense of wonder I experienced earlier had only increased. In fact, I didn't even know that kind of wonder existed in the world.

While in Colorado, I penciled a drawing of a nearby beaver dam, which was photocopied for all the counselors—a freeze-frame of one idyllic moment. I have hanging in my kitchen a watercolor of the silver chalk cliffs that surrounded us that week. A gift to my husband from his friend Jim, also a notable writer, who was with us on the trip. Jim has gone on to be with the Lord, but his art survives him in many ways and still blesses us every day by reminding us of those wonder-filled days.

We returned home, and only a few weeks later in August, I took to the skies again to travel to New York. On this trip, I learned God's majestic work takes on many forms and that God would continue to speak to me about His grace.

Room with a View

As I boarded the plane, a verse I tucked away in my heart earlier that morning came to mind—a familiar verse: "And we know that in all things God works for the good of those who love him, who have been called according to his purpose" (Romans 8:28).

While in the air, the captain came on and said we were very fortunate not to experience any turbulence while cruising, because from monitoring the radio, turbulence occurred at every other altitude. As far as things working for good, the calm gave me a chance to think about the week ahead instead of being consumed by my fear of flying. I'd never had a room with a view in the city, always just a brick wall, but I had begun writing songs in my spare time, and I wanted to work on one that had to do with my experience there. So I prayed God would give me some sort of window onto the city that week.

I had been a church musician since I was twelve years old, the reason being that the pastor's wife (oh, the stereotype of the piano-playing preacher's wife) moved away with her husband to another appointment. I had a salvation experience with God around that same age as well, but I still had not stepped down from the throne of my life and given God control. That didn't happen until the night in the shower I referenced earlier, just after I started working for Franklin's.

Immediately after that evening in the shower, something bizarre happened with my music. I had been chained to the notes on a sheet of paper my whole life but was now penning songs

with only chord charts, and playing them in front of others without suffering a nervous breakdown.

This seemed miraculous and opened up a whole new way for me to express God's working in my life as opportunities for me to share these songs began to increase. I began singing at church services, women's events, and even civic clubs—so much so, it became a challenge to fit everything in with my work schedule and travel. A new song almost always circled in my brain, waiting for attention.

When we arrived at the Sheraton Centre on Fifty-Second, we found there had been a mix-up, and the rooms we were supposed to have were not available.

"No problem," the desk clerk said. "We'll give you a better room."

I cleared my throat and braced for the result. I wondered if his idea of better was the same as mine.

I wanted a room with a view—but within limits. I didn't want to spend forever coming and going in the elevator, and oh, yes, that thing I had about heights. They creep me out, and I usually have to be dragged kicking and screaming to ascend them. The mountain climb of weeks before had been one step at a time, and I never came to a lookout point that seemed overwhelming until we reached the top. By then I was too overcome with the beauty of it all to care. The only elevator in the town I grew up in was in a three-story department store and moved so slowly, you could catch up on your reading while it groaned its way to the top. That was my provincial frame of reference for elevator speed.

The clerk handed me the key (hotels still used keys then). He smiled broadly, proud of himself. "Forty-fifth floor."

Be still my heart. No way was I going to spend the entire week in the sky. And the elevator ride? Have mercy.

"But. . ." I started to protest, but my companions were so elated about their rooms, I was too embarrassed to say anything. "Never mind," I said, resigned to my fate.

I dragged myself to the elevator, faced the music, and pressed the button with the number forty-five on it in the express. Always the express. I didn't know which I hated more, jerking up and down floor by floor in manually operated elevators or flying up the shaft like an exploding rocket in the expresses. I slumped against the back wall and braced myself like an astronaut preparing for liftoff.

I'd dressed up as an astronaut the fall of my seventh birthday—an unusual thing for a girl to do in the sixties, but John Glenn's orbits around the earth had sparked an adventuresome spirit in me. What was I thinking then? Where had this adventurous girl gone? Now adventure was coming at me like a freight train, and I wanted to run. The years between then and now had helped me hone my fears, but it seemed I was either going to have to face them or die.

I reminded myself I had just climbed a 14,000-foot mountain and lived to tell about it. What was 450 feet compared to that?

The elevator doors closed, and we gathered steam as we passed floors on the way up. I watched the numbers fly by—15, 20, 32. I always wondered if the elevator could gain so much momentum that it would not be able to stop and just explode through the roof. That kind of thinking, my friends, is where imagination—or ignorance—can take you. The elevator slowed in the forties, and my colleagues exited one by one. My room was on the highest floor. Wouldn't you just know it? Finally, the number 45 appeared in the display panel. The doors opened and I trudged out.

I inserted the key into the lock of my door, stepped in, and couldn't believe what I saw. The sun had begun its descent and spilled over all of Central Park. I had a front-row seat with not even a shadow of another building between the view and me. The golden glow of the celestial orb lit up the park, and in the entire city, there could not have been a better view than the one I had that evening and the whole week. I stood there with tears.

Again, with an overwhelming sense of "How could this be happening to me?"

My fear of heights seemed to melt into the floor, and my little hick-from-the-sticks self collapsed on the bed in awe.

Just weeks before I had gone to sleep with a gurgling stream every night and stood on top of one of the highest peaks in the country. This evening I would drift off to the honking of horns with a city oasis below me.

In the days ahead, I never closed the curtains. I went to bed with Central Park and woke up with Central Park. I noted the nuances of cloud and sun. When the rain poured, I still thought it spectacular.

A sliver of light sifted through a crack in the door. I was back to that grace thing, the lavishness of which was beyond my understanding. Up to that point, it had been a shoulder-to-the-wheel, pick-yourself-up-by-the-bootstraps kind of life, because a strong work ethic was a characteristic of my English, Scots-Irish heritage.

I had not earned the wonder at the top of the mountain nor at the top of this building and certainly did not deserve it. It shook me to receive this beauty. As far as God using everything for good, He had even taken the room mix-up and made it into a wonderful gift.

I can hardly think of those back-to-back trips and their very different but equally astounding sources of beauty without tears and an overwhelming sense of God's orchestration and grace.

Oh, and I did write a song from that time, which I sung many times in the following years, and it even made it into one of my recording projects.

I wish I could say that since that time, I have always fully and completely embraced the grace of God, but it continues to be one of the areas in which I struggle the most. It's hard to push down those roots that say you're undeserving and that you have to earn

it all. Recently author Mary DeMuth[6] has written, "We don't have to check off a list to be accepted by God." I love that.

As I write today, I'm sitting outside in early January. After several days of frigid temperatures, it's in the sixties. I can see the reflection of the tree behind me on my computer screen, and rather than being a distraction, it seems as if I'm enveloped in God's creation.

Yeah, it's all grace.

Lost (Not the Television Show)

Mrs. Austin, a buyer I came to know while temporarily working in one of our smaller stores, seemed to exemplify everything a godly mature woman should be, and I found her to be quite an encourager in my spiritual growth as one of the few I knew who for sure loved God.

Though I looked up to her for advice on my spiritual journey, in our business travels, she counted on me to get her where we were supposed to be. Near retirement, she did not enjoy the travel as much as she once had and was content to let others handle things. Sadly, one night while on a trip to the regional apparel mart in Charlotte, North Carolina, I let her down.

In the pre-GPS days, I had a unique way of arriving where I was supposed to go in a big city. I studied maps and had a fair working knowledge of how the places we traveled to were laid out, so often, if I needed to navigate back to our downtown hotel, I simply headed toward the tall illuminated buildings and kept making turns. This usually worked for me. If I meandered, well, no worries, it helped me learn my way around. I had not considered what that might feel like with another person in the car.

So one evening, after a day in the market, I picked her up for dinner. While returning, my plan went off the rails.

To make matters worse, the company vehicle had been unavailable, so we were in my personal car—a tiny English sports car—a yellow Triumph TR6 convertible. If you are not familiar with the automobile, it boasted only two seats poised about six inches off the pavement. It even had a plug in the floorboard,

which was a nod to the fact that whenever it rained, water streamed down the inside, I repeat, inside of the windows.

It was akin to riding on a pillow strapped to a skateboard.

I loved the car and had grown used to its idiosyncrasies—so much so that when it gave up the ghost, I found another one in British racing green, but I can't imagine what someone unaccustomed to it might have felt riding in the seemingly toy car.

Here is what happened.

We were talking, and I wasn't paying attention, so I missed my turn. No problem, I thought. I will just circle back around, but the turn I made did not take me where I thought it would. As poet Robert Frost wrote, "way leads on to way."[7] I did not want to scare Mrs. Austin by telling her I had no idea where we were, so I made light of the situation.

We were lost. I am not talking about kind of lost. We were lost, lost. No amount of looking at the tall buildings seemed to make it any better.

The sun had said goodbye quite awhile ago, and we were in a part of town that I did not feel comfortable asking directions. I commenced to pray. Hard. All without letting on how clueless I was as to how to get back. I still have an image etched in my mind of Mrs. Austin's silhouette against the city skyline as we kept circling the same ground.

Every time we would come upon the same landmarks, I would say, "Oh, look at that, guess I'd better try it again."

She was probably terrified, but she never let on.

Well, God came through, and we at last made it back to the hotel. I still do not know how, except by His grace and mercy.

Years later, I met up with Mrs. Austin again in Charlotte. Thankfully, our Charlotte experience had not seemed to leave a lasting mark. When I returned to my room that night, I wrote, "I rejoice there is a person like her. She'll wear the shiniest crown. If I could only be as humble, as meek as she is. I pray for grace."

I do not know if I will ever be as humble and meek as Mrs. Austin was. That is a tall order, but I am thankful for her incredible influence in my life.

Since that night in Charlotte, I have been lost many times. A few of them, it felt as if I were lost, lost.

After a friend took her own life one tragic day years later, I suffered from post-traumatic stress for over two years. I felt I had lost all ability to navigate my life in this uncharted, grief-filled land. Lost, lost.

But of course, in ways I could have never predicted, God got me home to peace and joy again.

The Israelites complained bitterly to their leader Moses, "Why didn't God let us die in comfort in Egypt where we had lamb stew and all the bread we could eat? You've brought us out into this wilderness to starve us to death, the whole company of Israel" (Exodus 16:3 MSG). They felt lost, lost. Yet, from our historical perspective, we see the faithful and miraculous hand of God in their journey to the Promised Land. We know God never failed them and ultimately fulfilled all that He had declared.

In the same way, He will not fail me or you.

Mrs. Austin passed away many years ago, and I am sure she gained that shiny crown to cast at Jesus' feet. It probably has an extra big jewel for putting up with my antics, especially that one evening in Charlotte, North Carolina.

What I Learned from a Beauty Queen

The executive vice president of our group of stores, which numbered a couple of dozen, made the decision that we would provide a wardrobe for the reigning Miss Georgia-America. She would select the wardrobe exclusively from the store where I was based, and I was the person assigned to coordinate it with her.

This meant I had to drop my own work for almost an entire day.

Now, I realized it was an honor to be selected to do this. On the other hand, orders waited to be written, previously scheduled appointments with sales reps had to be cancelled, purchase orders requiring follow-up would have to wait, and advertising had to be finished before she arrived. I needed to get used to this assignment, because I would work with many, many more Miss Georgia-Americas in the years ahead.

This endeavor also required that I get over my beauty queen prejudice. Logically I knew that the stereotypes often associated with them were not fair or right, but I still battled those perceptions in my own mind.

I tried to adjust my attitude so that I would be upbeat. I didn't want her to feel I was begrudgingly doing this, because that perceived attitude might transfer to the company I worked with. That's the last thing I wanted. This was a goodwill gesture, and I needed to have goodwill.

Having not seen a picture of the current Miss Georgia-America, I didn't know what to expect, but once more I couldn't imagine the remarkable experience God had in store for me. This woman would be one of the most memorable people I had ever met.

Her name—Kristl Evans. She was beautiful, smart, and (I had heard) very talented musically. But these things alone are not what made her memorable.

A scar extended across her right cheek—so prominent that makeup did not conceal it, and your eyes couldn't help but wander to it when you met her.

Yet, she possessed an almost disarming grace and ease. As we perused dress and sportswear racks trying to put together a wardrobe she intended to carry with her on a USO trip to the Mediterranean, she drew me in with her winsome personality. She seemed oblivious to the mark on her face.

I will never forget someone, maybe a reporter, asking her about it. "Oh," she said, "the scar is like an old friend."

An old friend?

What an incredible perspective.

Her response found a place deep inside of me.

I had scars, too. One, a forceps scar on my own right cheek, was a gift from my birth when my ten-pound, eight-ounce self, reluctant to make an appearance on the planet, was pulled unwillingly into life here. But, makeup helped diminish its prominence, so that scar did not present a real challenge.

It was the scars inside that haunted me, the ones no one else saw—some from things done to me and others a result of my own sin. They caused me such pain, I wanted to erase them, to hire a surgeon to eradicate their presence. The enemy of our souls used those scars to whisper messages of defeat to me, to remind me of my own poor choices.

Yet, Kirstl Evans had said her scar was an old friend.

How would I ever see my own internal scars as old friends, as she suggested?

Again, that word—impossible.

I heard Pastor Charles Stanley on the radio one evening and he provided an insight that helped me make the transition. I later found his words online. "We can view our scars as monuments to God's grace. . .proof of our spiritual healing."[8] He suggested that when the enemy comes against us, we should be thankful for the reminder of that place where we had experienced the outpouring of God's mercy, love, and grace.

So, instead of seeing scars as the place of our failures or injury, we could see them as reminders of where God's mercy redeemed us. That flipped it for me.

In time, I could say with conviction, "Therefore, there is now no condemnation to those who are in Christ Jesus" (Romans 8:1).

Kristl Evans was the first person to put me on this healing trajectory. In her own life, she could have hired a plastic surgeon to smooth over the line on her face, but she didn't. She couldn't get rid of an old friend. That old friend saw her all the way to the Miss America Pageant, where she was named second runner-up.

She continued to participate in USO tours and more recently teaches English as a second language to immigrants and refugees in the nonprofit sector.[9]

She helped me speak a different language as well, and that is God's language of redemption—that nothing is beyond His reach, nothing too hard for Him to redeem. It would be beneficial to not only me but to many others with whom I shared it.

As I said, there were many Miss Georgia-Americas to follow— all incredibly talented and beautiful. But I remember Kristl most of all, not because of her perfection, but because of a perceived flaw.

Stanley again: "People who still bear scars from past sins often become the most effective at leading unbelievers to know Jesus as their Savior."[10]

Spiritually speaking, God can take us, scars and all, use that thing which Satan wanted to destroy us with, and make it an instrument of His power, love, and grace.

Kristl, thank you for the powerful gift of perspective that you gave me.

Breakfast at the Waldorf

I never made a list entitled "What I Want to See in New York." Maybe I should have, but I did try to do at least one thing beyond the usual routine. Sometimes, though, I had too much do in too little time. A big motivation for using the time wisely as buyers came in the form of something called "profit incentives." In other words, the more money we made for our company, the more money we made in return.

Even so, when the invitation came to eat breakfast and attend a lingerie fashion show at the iconic Waldorf Astoria, I was all in. Even though I didn't buy lingerie at the time, I had to eat breakfast somewhere. I accompanied another one of our buyers to the show.

In my mind, it would be what we sold in our stores—bed jackets, rosebud-embroidered gowns, quilted shiny bathrobes, and flowing chiffon negligees. Things Aunt Bee or Doris Day would have worn.

But there was another wave coming that I wasn't quite aware of, and it had a flagship store on Fifth Avenue, sending shockwaves throughout the lingerie market. This influence would affect what I saw on the runway.

Again, I didn't buy lingerie at the time, so I didn't know. I was just going to the Waldorf Astoria to eat breakfast. . .and was really excited about it.

On the one hundredth anniversary of the hotel, Knight Ridder/Tribune News Service reported, "It isn't the biggest hotel in New York, nor the most expensive. But when it comes to prestige, the Waldorf-Astoria has no peer. When presidents come to

New York, they stay at the Waldorf-Astoria. Kings and queens make it their home away from home. Some of them liked the hotel so well, they made their home there."[11]

If you've ever had a Waldorf salad, Thousand Island dressing, or eggs Benedict, you can thank a chef at the Waldorf Astoria.[12]

There, history has been made, treaties signed, and agreements made.

I hoped to make a little history of my own.

When I arrived at their doors on Park Avenue that morning, I entered into what was one of the most captivating interiors I have ever seen. I just remember blue and mosaics. So stunning. As an art major, I would have been fine hanging out in the lobby examining all the intricacies of the work that made the space one of the most elegant in the world, but we needed to move on to the Grand Ballroom where the show would be held.

I didn't have a frame of reference for the opulence of the Grand Ballroom, except maybe my visits to the Vanderbilt's Biltmore House in Asheville, North Carolina. I buttered my croissant and studied the four-story height and sixteen-foot crystal chandelier, which gave meaning to the term "Grand."

Smitten by my surroundings, I had trouble concentrating on the business at hand—the fashion show. As I started to focus, I found it began as I had thought it might, with silk and satin, but as the show progressed, the influence of that previously mentioned trendsetter in the lingerie market surfaced, and I wound up a little annoyed with myself that I hadn't seen the flashing skin coming.

It might be hard to understand now, but at that time, the lingerie industry was more of a modest staple business, and the world had not yet moved in the direction it is now, at least in the mainstream. As my husband says, the Sears and Roebuck catalog lingerie pages were about as risqué as it got in your everyday life, unless you were particularly seeking out that sort of thing.

If I learned anything that day, it's that no matter how beautiful and enchanting the wrappings, if purity is lacking at the core, you can walk away hugely disappointed. Though I had loved the mosaics and the art deco influence in the hotel, I left feeling as if I had been blindsided.

That evening I wrote in my journal, "There's a spiritual battle, and this city screams of sensuality. I pray to be rightly centered in the Lord."

I wonder if at the time I thought I would fight that spiritual battle and win once and for all. I was only beginning to understand the battle would continue throughout my life, and I would have to come repeatedly to the throne of mercy and "find grace to help us in our time of need" (Hebrews 4:16).

I needed to avail myself of that armor of God Paul talked about: "Put on the full armor of God, so that you can take your stand against the devil's schemes" (Ephesians 6:11).

While traveling to the city, I repeatedly experienced the effects of the unseen battle waged in the heavenly realm, the battle "against the spiritual forces of evil in the heavenly realms" (Ephesians 6:12). But God was teaching me to look not at the physical battle before me, but to Him. I didn't feel strong. For good reason. I needed the strength only God could give to empower me for the life to which He had called me. I needed to equip myself to stand in the midst of the warfare around me. This would be essential in the years ahead.

As Christians, we are to be the salt and light Jesus talked about in Matthew 5:13–16: "Let me tell you why you are here. You're here to be salt-seasoning that brings out the God-flavors of this earth. If you lose your saltiness, how will people taste godliness? . . . You're here to be light, bringing out the God-colors in the world. God is not a secret to be kept. . . . If I make you light-bearers, you don't think I'm going to hide you under a bucket, do you? I'm putting you on a light stand" (MSG).

As salt, we preserve the truth in this world, as well as enhancing the beauty and wonder of all that God has done. Additionally, as lights in the darkness, we illuminate the path for others to find their way to Him.

Breakfast at the Waldorf didn't turn out as I thought it might, but perhaps God used it in a greater way to remind me once more of my great need for Him and His purpose for me.

The Maniacal Elevator Incident

Through the years, we often stayed at what began as the Hotel Pennsylvania, built in 1919 across from Pennsylvania Station and Madison Square Gardens. Situated on Seventh Avenue, close to the garment district, staying there meant we didn't have to walk those twenty blocks back and forth every day compared to staying at the other hotel on Fifty-Second. That was the upside, but believe me, this old hotel had its eccentricities.

I loved its history, though. Its phone number, PEnnsylvania 6-5000 has been in use longer than any other New York phone number.[13] While performing in an extended engagement there, Glenn Miller's staff arranger, Jerry Gray, wrote a song with the hotel's phone number as the title, and Glenn Miller's band made the number famous when they recorded it.[14] An Andrews Sisters version followed Miller's recording, making the number even more memorable.[15]

The hotel's wonderful stories helped me look past its oddities. During our stays there, it changed ownership several times, which made for unpredictable experiences. Some good and some not so good.

This story is about one of those not-so-good times.

We noted at our arrival on one particular trip that several of the elevators were cordoned off and out of use.

Routine maintenance I told myself.

I tried to minimize what the problem might be, because as has already been shared, I wasn't a big fan of elevators. In addition, I was particularly not a fan of broken elevators.

You can imagine my relief when we left for the market the next morning and found all the elevators in working order.

Or so we thought.

A fellow buyer I'll call Denise and I returned to the hotel on Monday afternoon, worn out from a hard day in the market. How can that be, you ask, when all I had to do was pick out pretty, pretty clothes?

Yeah, that's what everybody thought. Fact is, my job was a lot more complex than that. I had a monthly open to buy—that dollar amount broken down into departments; those departments broken down into individual items. What I bought had to fit into the plan I'd made or otherwise I'd have too much merchandise coming into the store at the wrong time or not enough to make sales goals. I might have too many knit tops and not enough shorts to go with them. In addition, all of the sportswear separates needed to be in colors that worked together. At that time, I prepared yearly budgets for about fifteen departments. Years later, it'd be ten times that many.

Additionally, I could spend hours in the market and not find anything I thought would work for our stores. Not a matter of what I liked. I had to buy what the customer liked—a task that sometimes required superhuman predictive skills.

That Monday afternoon, my head ached, my Barbie Doll feet hurt, and as much as I loved my briefcase, all I wanted to do was put it down after walking all over that part of Manhattan. Mondays could be that way even in the fashion district.

Denise and I trudged into the hotel and hit the up button on one elevator in a bank of about eight.

The elevator light lit up, dinged, the doors opened, we stepped in, and the doors closed—the last normal sequence I would experience from that elevator.

Denise pressed the number nine for our floor, and the elevator began ascending, then at about the fifth floor, for no reason, it began descending.

Denise and I exchanged glances and laughed. "Let's press the floor number again. It's probably just a glitch," I said firmly pressing the number nine. The elevator once more resumed ascending. Just as we breathed a sigh of relief, it overshot the ninth floor and kept going up.

Simultaneously, Denise and I reached for the nine and pressed it. We both attempted the same nervous giggles again. *No big deal,* I told myself, trying to eschew the memory of those cordoned off elevators. The elevator reversed direction and descended, but not a normal descend. It felt as if it were suspended on a giant rubber band and began going up a floor, down two, up three, down four.

Now, this hotel had twenty-two floors, which meant the elevator had a lot of room to play with.

What was that number again? PEnnsylvania 6-5000.

This was before cell phones, so we probably should have hit the red emergency button, but for whatever reason that didn't occur to either Denise or me. I guess we thought we could fix it ourselves.

I began reading the same panic in Denise's eyes that I fought back myself. We stumbled to the floor panel. "Let's just press all the buttons. We'll get off on any floor we can stop at and take the stairs." I paused a minute. "If it ever stops." I could see us growing old together in this giant bungee ball. We punched all the buttons until they glowed.

Where was Glenn Miller when you needed him?

Finally, after probably several minutes but what seemed like hours, the elevator stopped. I can't remember which floor, but I know it wasn't ours.

The doors opened between floors. We stared at the inside of the concrete shaft. We crawled out anyway and started looking for the stairs.

We'd been told to never take the stairs in this hotel, but the danger of a robber lurking in the stairwells seemed to pale in

comparison to the possibility of spending hours in a maniacal elevator. After all, I was prepared. I had my trusty briefcase with me. It had already defended me against an attack on the street.

I can't remember what happened after that. I know we probably reported the situation to the front desk and likely took the stairs for several days.

Since my days tapping in my heels across the pavement on Seventh Avenue, there have been times when life felt as if I were still stuck in that elevator again. Up and down, with no relief in sight. At our house, we've faced cancer, both my husband and me. He has had a heart attack. At times, we've had serious financial challenges. As I mentioned earlier, I suffered from post-traumatic stress for two years. We've seen family members and friends die. But we've also celebrated birthdays, graduations, awards, books published, and births of grandchildren. Up and down. Up and down.

In Hebrews 13:5, God promises, "Never will I leave you; never will I forsake you," even and especially when life feels as if we're in a giant bungee ball. Through it all, God is with us to comfort and uphold us. It may feel as if the elevator has stopped between floors, but it has still stopped, and God has faithfully provided a way out.

You may be reading this on an E-reader, or perhaps you hold an actual paper book in your hands. The publication of this project itself represents an elevator ride. Just as I finished the second draft of this book and started to put a proposal together, I had a freak accident. I tripped at a restaurant, went headfirst into a concrete curb, suffering a concussion, a laceration requiring stitches, and a broken arm. Miraculously, I had no brain injury, and though at first I was headed to surgery for a screw in my arm, a trauma doctor intervened and said he didn't think it necessary. Saved. Already suffering from carpal tunnel in my right hand, now my left was out of commission for a season. I continued pecking out corrections with one finger until rehab helped me

regain the use of my left hand. The writing life is full of ups and downs, which sometimes seem without reason, but with perseverance, hope, and God's grace, I have thankfully made it to this point.

You know, Glenn Miller had his ups and downs, too. He struggled for years to find the sound he wanted, barely scraping by financially, but when he finally discovered it, he became one of the most popular big band conductors of his time and went on to become a legend. Maybe even in part due to his time at the Hotel Pennsylvania.

Since the years when I traveled to the city, the former Hotel Pennsylvania has come under danger of demolition more than once, and many have labored to protect it as a New York landmark. Currently, it's not under the threat of the wrecking ball, and the present owners are investing to restore it to its former glory.

I'm sure they started with the elevators.

Whoever Heard of a Jewish Carpenter?

I pushed against the glass door of a sportswear showroom, hoping they had an open appointment so I could review their blouse line. Already on the floor seeing another resource, I thought it might be worth a shot. Oddly, things seemed to be a bit in disarray—walls primed but not painted, trim stacked up but not cut. Were they even open?

A sales rep appeared.

"Hi, I'm from Franklin's, and I'd like to see the new spring line."

"Sure," she said motioning for me to take a seat at a table. "Sorry about the mess. The contractor is behind." They had moved to a larger space from another floor.

I nodded and we shifted quickly into reviewing the line of mostly polyester blouses in assorted prints and solids—a line I considered more suitable for our mature customers, but a solid moneymaker. (I write this all the while realizing that I am today the age I thought I was buying for, and I still wouldn't put on one of those poly blouses. So there, younger me.)

I found it difficult to focus, though. Beside me at an adjacent table, another buyer had also just taken a seat. The sales rep that came to help her was not so brief about the state of the showroom. He began to rant. "I can't believe how hard it is to get construction work finished on time. Would you look at this disaster?" He waved to the unfinished work, grunting his exasperation. I took

from his attitude that maybe he wasn't just another sales rep but an owner or partner in the business.

If I'd been struggling to concentrate before, what he said next almost caused me to fall out of my seat.

"Yeah, all this work is being held up because my carpenter is taking the day off. It's a Jewish holiday." His mocking tone shocked me.

He paused a moment and laughed incredulously. "Whoever heard of a Jewish carpenter?"

My brain kind of froze.

"And this style," my sales rep was saying, "is available in a myriad of jewel tones." She waved a button front silhouette with long sleeves.

I stared at the blouse without seeing, because all I could hear was, "Whoever heard of a Jewish carpenter?"

I shook my head trying to process. I wanted to wave my hand and say, "Pick me, pick me. I know a Jewish carpenter. His name is Jesus."

I wasn't in Kansas anymore. Or Georgia. This crowd never had all that cultural Bible Belt indoctrination, so they didn't know Jesus was Jewish, and that until he started his ministry at around thirty, he lived the same life as his father Joseph—a carpenter.

I don't remember how long it took me to regain my focus, if or how I may have responded, but when I returned to my hotel room that night, I made a point of recording the story in my journal.

This experience reinforced my perception that most of the people I met in the market had never heard of that Jewish carpenter who changed my life. The entire time I shopped the markets of New York, I don't remember meeting one other person I believed to be a Christian. I know they probably existed, but I never found them. It was not until I attended church services in the city that I found folks who were like-minded.

Where and when I grew up, I hardly imagined I knew anyone who didn't know about Jesus—even if they had never been in a church. My friend, Skip, the Young Life director who also ran the camp I mentioned earlier, wisely observed that in the Bible Belt, we were inoculated against the gospel. We had a little experience, and that often shielded us from a true experience of saving faith. My friend hailed from another part of the country and experienced the ramifications of living out his Christian faith there and how to profess Christ meant hardship.

Not so much where I came from, but as he said, sometimes we thought attending church and knowing about God made us a Christian. Therein lay the danger. I suppose that's one of the reasons I had to drop nearly to the bottom of the well before I gave my life fully to God.

But when I did understand the extent of what Jesus did for me on Calvary, I wanted to let others know also.

Thinking I might have it repaired, I recently dug out that beloved briefcase I dragged around all those years. A seam had split, but the leather still looked great. My vintage-loving daughter might find a use for it. When I checked the inside pocket, I pulled out a stack of *Four Spiritual Laws*. These were tracts Campus Crusade for Christ produced to help folks share the gospel. I always had them with me. I'd buy them by the dozens, so I have no idea how many I gave out over the years. Back then, I struggled with how to share my faith with others, but I gave out those pamphlets because I took to heart those words of the great commission in Matthew 28: "Therefore, go and make disciples of all nations" (verse 19).

Burdened for many of the people I met, I was just beginning to learn the value of relationship as it pertains to ministry. Much of that teaching also came from my friend, Skip. With the exception of speaking events, most of the people I have been able to introduce to Christ were ones I developed a relationship with over time. Many of those alliances continue.

Today, I'm still sharing my faith, but in different ways (more about that later). Back then, I mostly felt my way along, trying to figure it all out, trying to let folks know about that Jewish carpenter. Who knows? Maybe a few of those *Four Spiritual Laws* found their way into the right hands at the right time.

Only heaven will tell.

It is interesting that now, the culture I live in, even in the South, is more and more like the one I encountered when traveling as a buyer. So, in yet another way, learning to navigate an environment that was apathetic, even hostile, to Christianity prepared me to live with courage.

God has been incredibly patient with me as I have tried to obey His calling. I have flat-out messed up so many times, but still He sends His Holy Spirit to be my guide and counselor all along the way, and I am so very, very thankful for that Jewish carpenter.

The Jet, the Met, and Who's Singing Now?

At the time I began traveling to New York, I had been involved in church music for a long time, as I said earlier—since twelve years old.

On a trip one August to Manhattan, a song I learned as a child became key to handling what turned out to be the worst experience I ever had in air travel—even worse than what I experienced on the return flight from West Palm Beach that started my big fear of flying. Well, at least that's when I thought it started. I had to also consider I wasn't big on flying because I was not the one flying the airplane, but that's a story for another book.

On the left of me in the plane, a female colleague, Beth, expressed her anxiety because she had just the week before sat on a runway for an extended period while mechanics hammered away on the jet she occupied. That memory did not bode well for happy future flying.

The well-dressed man on my right buried his nose in a stock sheet.

Beth and I chatted for about an hour, but in the last half hour of the flight, as we approached LaGuardia, we experienced a drop in altitude, which left us suspended about four inches above our seats.

The fasten seat belt light came on with a ding.

I was beginning to ding a bit myself.

The captain announced, "Looks like we're into a little choppy air."

No kidding.

"We have thunderstorms in the area, so I've turned on the fasten seat belt sign for a while. We may have a bit more ahead."

Oh no. The dreaded thunderstorms.

Turbulence is just a disturbance in airflow, I told myself. After many decades of flying, I knew it had been rare for turbulence to seriously affect an airplane.

But then there were those other thoughts, that wild stream of consciousness that raced through my brain—we're going to smack another plane, get dashed against a mountain peak, do a 360 in the air, break into pieces, lose our wings, have our shell peeled like a banana, have our tail fall off, etc., etc.

I fought hard to not let the crazy win.

Flight attendants disappeared to their seats, and we all braced ourselves, or at least I did.

A big bump and I lurched to my left. "A bit of turbulence," the pilot had said.

I'd like to know what he would call a lot.

As Beth and I tried to console each other, I noticed the man next to me wasn't doing so well, either. Pale. Sweaty. Bulging Eyes.

I tried to distract him, and please don't think I miss the irony of me, the ultimate nervous flyer, trying to console this man.

"Where do you work?" I asked him.

"I sing with the Metropolitan Opera, and I am usually in Europe this time of year." He paused a moment as we hit another series of jolts. "I wish I were there now," he said feebly.

People grabbed paper sacks.

Europe did sound nice.

Then, from the reaches of my childhood, a song began bubbling up in my spirit:

"Master, the tempest is raging! The billows are tossing high! The sky is o'er shadowed with blackness; No shelter or help is nigh."[16]

It didn't matter to me the song was about a boat—a storm was a storm.

The singer's hand gripped the armrest.

"Carest Thou not that we perish?" How canst thou lie asleep, when each moment so madly is threat'ning a grave in the angry deep?"

If I had ever been harsh toward those first-century disciples of such weak faith, they had my total sympathy now. I suppose if Jesus had been sitting in the aisle seat asleep right about now, I would have been standing beside him asking a few questions myself.

I turned to my right and said, "God is in control," saying it as much to myself as to the opera singer.

He peered at me with fear-glazed eyes, "I sure hope so."

I continued singing in my heart:

"The winds and the waves shall obey My will. Peace, be still!"

Another one of those drops in altitude. Screams from all over the plane. Honestly, it felt as if we were on a roller coaster.

Somehow, I tried to focus on the song in my spirit and managed to continue speaking with the Met fellow, trying to share God's love with Him, and also comforting my friend Beth, now very sick.

"Whether the wrath of the storm-tossed sea, or demons, or men, or whatever it be, no water can swallow the ship where lies the Master of ocean and earth and skies."

Swallow—now there's a scary word for you. *Oh, Lord, don't let us be swallowed by this thunderstorm.*

I forcefully directed my thoughts away from the word swallow to the word Master, and as I did so, a supernatural assurance and peace came over me.

"They all shall sweetly obey my will; Peace, be still! Peace, be still!"

In a few moments, we at last made our descent onto the runway. I pulled out one of my *Four Spiritual Laws*. When we were

on the ground, there was not much time with everyone rushing to get their overhead luggage, but I asked the singer if he would read it. He looked me straight in the eye and said, "As soon as I'm in a taxi, you can be sure I will."

That's the last time I ever saw him. I often wondered when I caught snatches of the Metropolitan Opera performing if he was among their number and if he ever read the pamphlet I gave him. And did he ever fly again?

My friend, Beth, did not stay with the company very long, and I believe she, too, wound up in ministry of some sort. It might have been that plane ride that became the turning point for her.

In any event, the song God brought to mind came from Luke 8:22–25. Jesus and his disciples had gotten in a boat to cross over to the other side of a lake. While going across, a storm came up, and the disciples panicked.

> " 'Master, Master, we're going to drown!' He got up and re-buked the wind and the raging waters; the storm subsided, and all was calm. 'Where is your faith?' he asked his disciples. In fear and amazement they asked one another, 'Who is this? He commands even the winds and the water, and they obey him' " (verses 24–25).

When those storms roll in, like the disciples I often go to my default setting—fear. But, if I listen for God, He always asks me to move beyond the fear to trust.

I cannot say that was the last time I felt afraid on an airplane, but God has helped me face my fears and do what I needed to do, and He has often used music to comfort me. On a trip back from São Paulo, Brazil, where my daughter and I had been min-istering in the favelas of Rio de Janeiro, a friend offered her CD player and a Rita Springer CD. I just kept pushing repeat on that long, long nine-and-a-half-hour trip. Music once more brought me the peace I needed. I even drifted off to sleep a little, which is

usually impossible. Years later, I would have the opportunity to meet Springer and share just how much her artistry meant to me.

So, Met singer, if you're out there, just know, though you may have not known peace on that airplane, I pray you will find it for all eternity.

Give My Regards to Broadway and Claude Monet

The orchestra swells, the lights go up, the curtains part, and. . .

When I transitioned to the next part of my life, if I had to name one of the things I would most miss about traveling to the city, it would be hearing the orchestra warm up before a Broadway show. That sound filled me with expectant wonder. On almost every trip I made, somehow, we managed to get tickets to a play.

The first show I ever saw—wait for it—*Annie* in its first run on Broadway. From Annie's musical commentary on orphanage difficulties to her wistful delivery on the sun's dependability, that show experience seemed to break the time and space continuum. Talk about suspending disbelief. I forgot where I was. Not since seeing *Mary Poppins* at eight years old had I been so transported by a performance.

That little red head had me humming all week.

Many more theatrical performances followed over the years— *42nd Street, A Chorus Line, Big River, Amadeus, Brighton Beach Memoirs*. The list goes on.

Some shows I have seen again on national tours.

However, none ever compare to the experience of sitting in the Imperial, Majestic, Eugene O'Neill, Broadhurst, Neil Simon or any one of the other Broadway theaters. One can almost hear the echoing lines from plays that have come before and see the

stars that lined their stages when you take a seat in these architectural charmers.

The last show I saw during those years, I do not remember because of the play itself. It had only a short run on Broadway, but I went to see it because of one of the stars, Mary Tyler Moore.

I thought I might toss that beret into the air, after all.

There she was, right up there on stage in *Sweet Sue*, in all of her big-smile glory. So starstruck, I hardly knew what she said, only that I was in the actual presence of this woman I had so long admired.

Happy.

Incredibly, as I finished writing this chapter, I visited in a hospital waiting room with siblings who awaited news of their mother's surgery. A nearby television was muted, but news bulletins flashed across the screen. I chatted with one of the sisters when another of them said, "Mary Tyler Moore died." I looked up and read the news on the screen thinking immediately of the words I had just written about her. I am incredibly blessed and thankful to have seen this woman perform on Broadway. She influenced me and many other women of my generation to believe they could indeed find their way, as her television show opening song alluded. Who knows how many more women today she continues to affect with her show in syndication.

We'll miss you, Mary.

In more recent years, I attended our local symphony's pop concert. Afterward, the conductor announced they were beginning a chorus. My children turned to me and almost simultaneously said, "Mama, you should do that."

So, I did.

In many ways, singing with the symphony chorus filled the empty place where that expectant wonder had been. The conductor of the symphony at the time had himself played for many shows on Broadway, and even worked with Leonard Bernstein.

In my mind, I could draw a straight line back to that time when Broadway shows were a regular part of my life.

Oh, how I still love to hear the orchestra warm up.

As compelling as Broadway shows were to me, I equally purposed to visit art museums— in particular the Metropolitan Museum of Art.

I could have lived in that place. My children and I later read a book entitled, *From the Mixed-Up Files of Mrs. Basil E. Frankweiler* about children who did exactly that. I was a bit jealous of them.

If we stayed on Thirty-Fourth street, getting to the museum could be a problem, but if our lodging was on Fifty-Second, well, nothing would stop me from navigating to Fifth Avenue if we arrived on a Saturday, early enough on a Sunday afternoon, or at that time, the museum was open on Tuesday nights.

One Tuesday evening, I stood before a Greek bust that dated from 0–35 A.D. A contemporary of Jesus sculpted this likeness of a young woman. It occurred to me that I gazed on eyes that might have looked into the eyes of Jesus. One of the most remarkable aspects of any piece of art is that it gives the viewer a window into the world of the artist.

I never left the museum without visiting the gift shop and buying a few prints.

We also made it to the Guggenheim one long weekend, its architecture a work of art in itself. We cruised the long spiral walkway leading to the top and took in all we could absorb of artifacts and creative expressions.

In these museums, I have seen works by Monet and Manet, Vermeer and Van Gogh, and stood in amazement at the art of the centuries.

These opportunities opened simply because traveling was part of my responsibilities as a buyer.

However, I had a very different idea of what my job would be like when I first took it.

I honestly believed when I first accepted my position that it was more in the business management trajectory. I didn't quite get the travel involved. But I believe God led me to this career because He knew the future and how all the experiences I had would shape me.

When God asks us to do something, usually we see only the next step.

But He's got it, because He does see the end at the beginning.

I often worked long hours, gave up weekends, and missed many things because of the work I did, but the cultural advantages that came with the job made those things worth it for me. In ways I couldn't have predicted, they helped set up what God would ask me to do many years later.

Several prints adorning the walls of my home today made the trip rolled up in a cardboard tube, riding in a 727 overhead compartment. Degas's dancers twirl across our upstairs hallway, Renoir's *Girls at the Piano*, in an on-the-nose placement, have presided over—you guessed it—my piano, and *Young Mother Sewing* by one of my favorite artists, Mary Cassatt, continues to float around the walls of our home. These and others have greeted me on the birth of my children and have been there when they graduated high school and college. These pictures are the wallpaper of our lives and speak to me of beauty that spans not only the years of our family but also the broader scope of time. Their presence in museums has blessed many for generations prior and hopefully will continue to bless generations to come.

I hope they have helped my daughter become the artist she is, and perhaps even more generations of our family will find their creative inspiration from the prints hanging on our walls.

The plays and the pictures I have seen fuel my creativity and help me avoid settling for living a black and white life, devoid of the artistry God longs to give me. Emily Freeman in her lovely book, *A Million Little Ways*, writes, "Artists . . . pull back the covering on our inner life, allowing us to see things beneath the

surface, things that, without their compassion, creativity, and generosity, we may have missed."[17] Something extraordinary happens when we awake to the purposes and artistry of God. It spills out into every aspect of their lives.

As I prepared to write these words, I flipped through a box of memorabilia and came upon a collection of playbills from so many of the shows I saw. I also have a stack of postcard-sized prints I saved from museum gift shop forays. I am thankful for the artists represented in these works who have helped me see the world in new ways and grateful for the amazing opportunities I've been given.

I have since heard McNair Wilson[18], former Disney Imagineer and one of the most inspiring speakers on creativity I've ever heard say, "If you don't do you, God's plan is incomplete because you're the only one who can do you."

It was beyond my comprehension then how much these experiences would contribute to the work I do now, how they helped me to "do me" and prepare me for the years ahead.

If you're wondering about the value of the situation in which you find yourself, I believe God doesn't waste anything. It may take time to understand the why or how, but ultimately God doesn't accomplish his work in spite of the experiences he brings our way, but because of them.

My Unlikely Expertise

If you can find a thing that hasn't had much attention, and give it a little nourishment, amazing results can occur.

That's how I came to experience success in a couple of areas that might seem unlikely.

I had often been accused of only buying clothing for people who were tall and thin like me.

Hah!

I tried not to resent that accusation. It took minimal skill to buy things only I wore, but it did take business acumen and fashion sense to figure out what other people liked and wanted to put on their bodies.

I saw the greatest business increases in a department that I had never worn and to this day have still not worn, at least yet—large sizes.

Many names have been used to describe this category over the years—full-figured, large sizes, plus size. I think the new label today is curve.

My mother wore these sizes. I grew tired of watching her order from catalogs, only having to often return items that didn't work. It has always been a challenge to guess what size you wear from a chart. Her other option at the time was to select items from what might be a four-way rack shoved in the back of misses sportswear. If you didn't like navy or black, too bad. Evidently, retailers often thought that if you weren't a size six, you didn't care about fashion.

We would see about that.

I decided to press the limits and take my miniscule budget in women's sportswear and see what I could do with it in the market.

What we found was that women were starving for younger, more colorful silhouettes and fabrics. Of course these days that is not news, but back in the day, it seemed groundbreaking.

We began to develop a steady clientele who valued our selections and customer service—my mother among them. I bought most of her clothes from those items I selected in the market. In fact, I could almost without exception pick clothes that would exactly fit her even better than she could herself. When my sister married, I hunted down a dress for my mother from New York backrooms while I shopped the bridal market. I wanted her dress to be as special as everyone else's. When I finally found the mauve accordion-pleated, lace-trimmed gown, I hand-carried it back on the plane.

It fit her perfectly.

So, all you folks who thought I only bought tall and skinny. Think again. When I looked at the profit margins in women's sportswear, it ranked as one of the most profitable departments under my responsibility.

Another area in which I developed an expertise was swimwear.

I didn't wear swimwear much either (not too many trips to the beach) but swimwear seemed a science to me, and if I could figure it out, I might make some money. Swimwear up to that point had been a bit of an afterthought with our company, which provided a great potential to expand the business.

First, it had to do with delivery. Bring in a few silhouettes early during the resort season to see what women were looking for, then when you find what sells, that's what you go after during the regular season.

Next, the fit. I heard it so much after a woman entered a dressing room with swimwear—moaning, groaning, and "This looks horrible." I aimed to fix that.

It would be challenging to find silhouettes that flattered a variety of shapes and sizes, but again, if I could do it, we could be successful.

I listened to what sales reps told me about what style flattered which body type, but some things I just had to learn by trial and error.

Eventually, one of the major swimwear manufacturer's reps would call me each year and ask me to come to the Atlanta apparel mart and go through his line with him to weed out the weak styles before market week. For this assistance, I was well compensated with off-price merchandise at the end of the season. A joy to work with him.

Yes, paying attention to neglected areas turned out to be a profitable enterprise.

In the spiritual sense, I had myself experienced a sense of being marginalized and pushed to the back corner.

After I had been writing songs for a couple of years, a church invited me to sing at a special event. I accepted the invitation with fear and trepidation (my usual response). But I prayed. A lot. I wanted this to be a ministry rather than a performance; not any of the old me but only God making Himself known through me.

As I sang that morning, I had a real awareness of God's presence and power. But when I returned home that evening, the old record started.

"You made a fool of yourself today."

"Who do you think you are?"

"Don't you remember what you did?"

Yeah, him again.

I dropped my head. I felt weak, unfit, and that I had humiliated not only myself but my family as well with my poor offerings. As I sat at my dining room table, I slumped under the attack.

At the time, I read the New Testament continuously, so I picked up where I had left off that morning in the words of Paul

to the Corinthians. First, 1 Corinthians 1:27–29: "But God chose the foolish things of the world to shame the wise; God chose the weak things of the world to shame the strong. God chose the lowly things of this world and the despised things—and the things that are not—to nullify the things that are, so that no one may boast before him." And then 1 Corinthians 2:1–3: "When I came to you, I did not come with eloquence or human wisdom as I proclaimed to you the testimony about God. For I resolved to know nothing while I was with you except Jesus Christ and him crucified. I came to you in weakness with great fear and trembling."

How amazing that this was the next thing I read. I had not gone in my strength but in my weakness, but the good news is that God used my weakness in a way that he could not use my strength. I felt marginalized, but His eyes were toward me to strengthen, nourish, and enable me to do what He had called me to do. I felt like that rack of women's sportswear pushed to the back corner, sad and forgotten, but He brought me forth and filled me with Himself.

So, if you feel pushed back, don't worry. God's expertise in bringing you forward is not unlikely, it's certain. Submit yourself to him, and watch what He can do.

Fashion Rules, the Early Years

Back in the day, in the part of the South where I lived, we had lots of fashion rules.

Don't wear white shoes, handbags, belts, dresses, slacks, or skirts before Easter or after Labor Day. The fashion police would most certainly turn on the blue light. Some even took it a step farther and wouldn't wear a white shirt outside of these dates—the same thing went for linen fabrics, straw handbags, and belts.

No white, red, or black at weddings.

Nothing but black at funerals.

Unless you wanted to be thought of as dead yourself, don't show up at church or any other dress-up occasion without hose.

Don't mix silver and gold jewelry or brown and black accessories.

Handbags and shoes should match.

Don't mix fabrics from different seasons. For example, you wouldn't want to wear a wool jacket with a chiffon blouse.

Colors should be seasonally appropriate. No brown in July or yellow in December.

Undergarments ought to color-coordinate and be in great condition lest you make that proverbial unexpected ER trip.

Don't mix plaids, stripes, or prints. Matchy, matchy.

So. Many. Rules. Exhausting.

I'm sure I have even forgotten a few.

In recent years, I have risen up against these rules. I've been seen after Labor Day in white pants. It's 107 degrees here, so who cares?

I recently made a trip to the emergency room, and believe me, no one cared about my underwear. They were far more concerned about the bloody goose egg on my head.

One of my favorite dresses to wear to an evening wedding is black. You can't spot me for all the other folks wearing black.

I have also now joined the host of others who have forgotten what it's like to wear hose.

I do not ever buy more than one garment off the same rack. No matchy, matchy.

Fashion should be a creative endeavor, but with all the rules we used to have, it's a wonder we could even get dressed in the morning.

The same is true with faith. If all we're doing is living by a bunch of rules, sometimes called *legalism*, we have missed what true faith is.

True faith is about relationship. If we could have lived by the rules, Jesus would have never had to die on the cross. He died so that we could be free from the bondage of the rules. That doesn't mean we cast off the Ten Commandments. No, it means we are free to walk them out in relationship with Jesus who gives us the power to obey Him. We don't do it in our own strength. We do it in His strength.

So part of the good news of the gospel is that we don't live by those soul-crushing rules anymore. We act out of our love for him and our desire to serve and obey him—not because we can check off an item on a list.

I have to confess that those old rules in fashion still haunt me, just as occasionally a legalistic bent in me will rise up, but I remember the words in Romans written by a man who had struggled with the law himself: "For sin shall no longer be your master, because you are not under the law, but under grace" (Romans 6:14).

When the perspiration is pouring down my face in September and I'm tempted to swap the white pants for the brown ones just

because someone who's long gone decided that's the right thing to do, I remember those old rules don't have anything to do with me.

And in the spirit, I need to always remember to cling to grace, not to a bunch of do's and don'ts, because Jesus has done everything for me.

Perimeter Pérez, Where Are You?

One Sunday afternoon, an unusually large contingency of us from our store climbed into the car of our merchandise manager, who I'll call Mr. Landon. Headed to the Atlanta airport about an hour and a half away for another New York trip, the company vehicles were all in use, so one of us had to leave our personal car in airport long-term parking. Mr. Landon was elected.

We cut it a bit close that afternoon, for reasons I don't remember now, but in those pre- 9/11 years, we didn't face long security lines. Usually, no problem. We'd check our luggage at the curb and head straight for the gate.

We had all become close on these trips, so as we rode, we talked about business, our families, and other topics. The ride was uneventful until we actually sighted the Atlanta airport.

That's when we heard it. That unmistakable sound. Bumpity, bumpity, bumpity.

A flat tire—only one exit away from the airport on I-285.

If you've never been to Atlanta, I-285 is the sixty-three-mile perimeter highway around the city. Traffic from I-85, I-75, and I-20 converge onto it. Even at that time, ranked as one of the most heavily traveled highways in the country, it was well on its way to being named in more recent times as one of the most deadly and dangerous highways in America. No one wanted to have a flat tire there. Changing it meant dealing with traffic streaking by at speeds that seemed close to those on the Autobahn.

The highway had become famous in 1982 when then pitcher for the Atlanta Braves, Pascual Pérez, decided to drive himself to a game at Fulton County Stadium. He had only recently gotten his driver's license and couldn't find the exit for the stadium. He evidently made several orbits around the city before running out of gas and finally calling for help.[19]

The Braves up to that point in the year had struggled (2–19) and though Pérez was set to pitch, when he didn't show up, Phil Neikro stepped up to the mound. Incredibly, the Braves won. No one could believe what happened next. They went on to a 13–2 winning streak and won the National League West Division title. I still remember all the newspaper coverage that called him Perimeter Pérez. Some think the humor of the incident changed morale so much, it altered the trajectory of the team. Later the team reportedly gave Pérez a jacket with I-285 on it instead of his team number.[20]

When we had our flat tire, I was having a lot of compassion for Pérez running out of gas on the highway. It didn't seem a bit funny to me at the time.

Mr. Landon edged over onto the shoulder, and we exited to inspect the damage.

The right back wheel collapsed sadly in front of us, as if it had just become too exhausted to carry on.

I turned and gazed at the airport terminals, so near. . .and yet, so very, very far.

I checked my watch—2:45. Our plane left at 3:20.

Now, we were in real trouble. Overbooked Sunday afternoon departures meant someone already waited at the gate to grab our seats. A few of my colleagues had in the past regularly scored free tickets for exiting overbooked flights and coming back later. I never did, because the aggravation of it all never seemed worth it. I dreaded having to go home and drive back to the airport in what would probably be the wee hours of the morning in order to have a full workday on Monday.

"What do we do?" someone asked.

"Change it," came the answer.

So, in our nice traveling clothes, we set to work.

My dad had shown me how to change a tire, so I was not entirely ignorant of the process. I'll be honest here, though, I didn't want to get my hands or my clothes dirty. Fortunately, Mr. Landon did the heavy lifting. Still, I felt I could be part of late NASCAR sensation Dale Earnhardt's pit crew, with how fast we worked.

First, make sure the emergency brake was on, then up with the trunk, and out with the luggage. I never packed light. I couldn't stand to not have the clothes I might need, so I packed for all contingencies. I think my colleagues may have followed that same plan. Lined up on the side of I-285, it looked like we were having a tag sale.

Then, pull out the tire and the jack.

Jack up the car. Hubcap off. Lug nuts off. Tire off. Tire on. Lug nuts on. Hubcap on. Let the jack down. Store the tire and tools. Put the luggage back in the car.

Pile in the car and screech off into traffic.

All the time checking our watches.

No way to know if we'd actually make our flight.

We tossed our luggage to the curbside check-in and streaked to the airport subway train that would take us to our gate.

Finally, we stumbled into the gate, barely able to breathe.

As we tried to take in oxygen while finding our seats on the plane, several other buyers from our stores were already seated. I became aware that they studied us. Our windblown hair, disheveled clothes, and crazed expressions may have given away something unexpected had happened.

When told about the incident, one of the women said, "You're not supposed to be on this trip."

I looked her square in the eye and said, "Oh, yes we are."

I hadn't just changed a tire on I-285 for nothing. I thought I might have earned a jacket just like the one Pérez had. Might

even set a new fashion trend, me with a big I-285 emblazoned on the jacket back in rhinestones or pearls.

On reflection, Pérez's orbits around Atlanta turned into something that may have fueled the Braves into the pennant race. In the same way, God can turn seemingly bad scenarios in our lives into instruments for accomplishing His purposes. In Genesis, we find Joseph's brothers throwing him down a well and selling him into slavery. But ultimately, Joseph rose to rule the land and save his own brothers and father from starvation. When reunited with his brothers, he said, "You intended to harm me, but God intended it for good to accomplish what is now being done, the saving of many lives" (Genesis 50:20).

In a couple of hours, I would face another unexpected twist in which God reminded me of yet one more important truth. In the meantime, I collapsed in my seat, relieved, and began preparations for the week ahead.

Running on Empty

The whole day had sped by like those NASCAR racers I thought about while standing on I-285. For once in my life, even the flight had seemed short. No sooner had we arrived at cruising altitude, we started our descent into LaGuardia, and I spotted the Manhattan skyline. My stomach rumbled, and even with the engines gearing up for landing, I noticed. I tried to remember if I had anything to eat since the day before. I hadn't. Too busy. The flat tire had cut my time too close, and I hadn't had the opportunity to eat at the airport like I usually did. But no problem.

I'll grab a bite after I check into the hotel, I told myself.

The plane touched down, and I began struggling with my seat belt even before we'd come to a full stop. Impatient. In a hurry.

Come to think of it, I hadn't had anything to drink but a little of the soda they brought me on the plane. Trying to make good use of the airtime, I had organized my briefcase for the week ahead.

My colleagues and I grabbed our suitcases from the luggage conveyer and sprinted to the taxi stands, trying to get ahead of the other forty thousand people who had just disembarked to head into the city. I coughed. My throat felt parched as I stood in the taxi cue line. I forgot how much flying could dehydrate.

Just as soon as I check into the hotel, I'll get a big glass of water, I assured myself. I could wait a little longer.

The taxi cue line seemed to stretch out for miles. Finally, our turn came to get a cab. We piled in and gave the driver our destination.

Despite the elevator incident, we were back at the hotel across from Madison Square. We kept trying to forget previous infractions to save our feet from walking so far.

When we arrived, I'd never seen it so packed. I think that same crowd of forty thousand people who left their planes when we did were all staying at this hotel.

The lines to check in spanned the entire width of the lobby. I always wondered why there was no seating in the lobby, just a long desk at one end. Now I knew. This many people would not have fit with furniture, too. As many times as I had been there, I had never seen so many people on a Sunday afternoon. Must have been a lot of conventions in town.

Wow, was I thirsty. I looked around. I could go to the coffee shop and get a drink, but that meant leaving my space in line. I hated to do that, so I continued to inch forward.

Then I had that feeling.

I had first experienced it coming in from recess when I was eight years old. It started as sort of a weakness, progressed to sickness, then everything went stars, and then black.

Over the years, it had occurred several times—once on a hot July day, I went down in front of Cinderella's Castle at Disney World.

It never happens when it's convenient.

By the way I felt, I knew the time had long passed to go to the coffee shop for water. I just needed to find a place to sit down. There was no furniture. So the floor it was.

I broke from the line and moved toward a partition that might obscure me sprawling on the carpet, but just as I neared it, someone pulled the shades.

Splat.

I must have only been out for a minute, but when I awoke, through the fog, I heard a voice yell, "You can't lie there."

Another voice responded, "Yes, she can, she just fainted."

"Water," I uttered. Magically, water appeared.

It's amazing what kind of results fainting gets, but I do not recommend it. I was so humiliated lying there in that Seventh Avenue hotel lobby. This was my own fault. Too busy to do what I knew I should to take care of myself.

Too busy. Period.

Many years later after my son was born, the situation became much worse. A doctor diagnosed me with a heart valve issue, which he said is often exacerbated by dehydration. "You've probably had it your whole life," the doctor said.

Nursing my son had even further dehydrated me, and I was not taking in enough fluid to replace what was lost.

I was learning that running on empty spiritually was not such a good idea, either.

I might have been tempted to think, oh, I'll skip reading my Bible today and read a little extra tomorrow. Or maybe I thought I didn't have time to pray, but when would I have time?

Next thing you know, I could be running on empty.

I learned the value of a consistent, unwavering walk with God, because you never know what a day will bring. Maybe even changing a tire on I-285.

Just as I needed water to keep my body running, I needed the Living Water to keep me spiritually strong. You would have thought I learned my lesson, but I still have the tendency to run myself to the edges even though I know the consequences.

The prophet Isaiah observed, "Those who hope in the Lord will renew their strength. They will soar on wings like eagles; they will run and not grow weary, they will walk and not be faint" (Isaiah 40:31).

So, take it from one who has done some fainting in her time. It may get you water fast, but it's always better to keep the tank consistently full.

It's Christmastime in the City

I turned my head to the skies as I approached 1407 Broadway. A snowflake the size of a small cookie kissed my face with cold wetness.

What was this?

Precipitation of an unusual kind.

I noted later in my journal they were the biggest snowflakes I'd ever seen. My frame of reference might have been a bit skewed.

People thought we didn't have snow in Georgia.

We had snow.

Why, every January we received about five pellets of ice mixed with three crystalline flakes. Seriously, back in the foothills of the Blue Ridge where I grew up, we had a foot of snow on April 1 of my sophomore year in high school. As you might imagine, that was about the extent of my winter weather precipitation experience.

The possibility of snow added to the magical feeling associated with being in New York near Christmas. The fashion markets dictated that we'd be there just before Thanksgiving every year when so many of the streets and stores were decorated.

And speaking of stores, I loved to steal a few minutes away during lunch or after the markets closed to take in their Christmas grandeur. Most often it would be Macy's because the store was close to the market. When I first walked into their giant store on Thirty-Fourth Street near Christmas, I gasped. The space still looked much like it did in the holiday film, *Miracle on 34th Street*. The soaring columns—the sparkle—the beauty. I supervised cosmetics at that point, and the mammoth first-floor cosmetics

department made me momentarily cringe at how many monthly inventory reports had to be filed. Let me digress a moment with a little department store trivia knowledge. I later learned that placing the profitable cosmetics right at the main entrances, as most department stores do today, was a concept initiated by Harry Gordon Selfridge at his London store almost a hundred years earlier.[21] So, the next time, you enter a store and an associate hands you a fragrance sample card, you can thank Harry Selfridge.

Women's accessories also occupied the first floor—bay after bay of designer handbags, scarves, and gloves. One November, I bought a deep-blue knit hat and glove set, which I enjoyed for many years and especially on that trip, because I had forgotten to bring warm accessories and the weather turned brutally cold. There's no way to explain how the wind can howl up and down those city streets in the winter.

I had never seen anything like Macy's wooden escalators made of oak and ash, which had been running every day for almost seventy years.[22] I enjoyed their clattering rhythm as they carried me from level to level, eventually landing on an entire floor dedicated to the Christmas season.

Can you say wonderland?

Nostalgic memories washed over me. For several years when I was a child, my family lived near the big rambling Sears and Roebuck store on Ponce de Leon Avenue in Atlanta.

At Christmas, we always made at least one pilgrimage to the brick-faced multi-layered establishment, in which they would transform what I remember to be one entire floor into a seasonal toy department. I'm quite sure Santa purchased my first bubblehead Barbie there, as well as her sports car and dream house.

I cruised Macy's aisles perusing the offerings of ornaments, music boxes, and home décor. I can't remember buying anything except one music box of a piano that I brought back to my mother. A tinkling version of Bach's Minuet in G played when you

twisted its base, but I also brought back many memories of that lovely store.

As I navigated around the city doing my work, I hummed, "Silver Bells" under my breath. Some sources say "the song's inspiration came from the bells used by sidewalk Santa Clauses and Salvation Army solicitors on New York City street corners."[23] Others cite a bell on one of the cowriters' desks as the inspiration.[24] Either way, it became the perfect soundtrack for many of my New York Christmas experiences.

As I trekked from Seventh Avenue to Broadway on my usual route for work, I would have rung a bell if I'd had one, but one November trip in particular, I could have used a bell the size of the one in Philadelphia to express my joy.

With all the excitement of the city, I could never forget why I was there. One of the reasons we came in November was to supplement our seasonal specials. Black Friday was so named because many stores counted on that day to move from a deficit profit picture into a positive one—a "black" one. It was my job to make sure I made as much money as I could for my store, and I would benefit from the endeavor as well.

We were at the corporate offices when we received notice about a sportswear vendor clearing out inventory. I rushed over to the showroom on Broadway to see what was happening.

"I'm interested in your off-price merchandise," I said after exchanging pleasantries with the sales rep in the showroom. Just wanted to make sure he understood we weren't fooling around here. He nodded and began pulling out sweaters priced so low, I almost couldn't believe it. I inspected the garments for quality—the seams, the yarn, the stitching. Any vendor would be less than brilliant if he sold one of our buyers deficient merchandise. All we had to do was report to our corporate offices, and the vendor would be in jeopardy of losing any future business. . .with 400 stores. It just wasn't worth it to try and unload something on one of us.

I made notes of several styles and then asked how many dozen he had left in stock. He told me. I made mental calculations.

"Are these available for immediate delivery?" I clutched my order pad, waiting for the answer. The last thing we needed was this kind of merchandise coming in after Christmas.

The sales rep nodded yes.

Right there, I had to make a decision. I prayed a silent prayer. On paper, I would for a time significantly exceed my buying plan open-to-buy. This was the monthly print out which showed me how much money I had left to spend in every department. Figures in brackets denoted that the buyer was overspent. I was looking at some serious bracketed numbers here. Retail prices had to be established before they were discounted, but in the end, I would turn a great profit.

In the boldest purchase I ever made, I bought almost the entirety of his remaining stock. Hundreds of dozens.

When the merchandise came in, it flooded stockrooms from the floor almost up to the eighteen inches of space that the Occupational Safety and Health Administration required between storage and ceiling sprinkler deflectors. When I inspected the stockrooms, a little perspiration began beading on my brow as I turned sideways to get through the cardboard jungle.

This was a lot of merchandise. And my open-to-buy report wasn't looking so great either, with those high retail prices showing up.

Later, the beads turned into plain old sweat drops when I saw my boss coming out of one of my stockrooms.

My eyes darted to the nearest exit—still time to run, because I was about to get it. I anticipated a chewing out unlike any other I had ever had. I managed to stand my ground even though my mouth felt dry and my hands shook a little. He approached me, "What did you pay for that?" he said, curtly pointing toward the stockroom.

I told him.

"And what do you anticipate selling it for?"

I told him.

A smile eased across his face. "Carry on," he said and walked away almost with a jaunt in his step.

Where's a bell when you need it? And did I see a snowflake or two outside on that balmy November day in Georgia?

Christmas lasted a very long time that year as a very special gift came my way in the form of a profit incentive check in February—an extremely nice one due in part to that big purchase the previous November. Those sweaters had almost flown out of the store.

Made me want to ride a wooden escalator, buy a music box, and crank up a little Bing Crosby singing "Silver Bells." But hey, I'd even take a cover version of the song—The Carpenters, John Denver, or even Elvis.

Getting ready for Christmas could be so much fun.

And yet, getting ready for Christmas also presented problems. For almost ten years I spent the Christmas season in a business that capitalized on a religious holiday for profit. With all the Christmas preparations in the business arena of my life, at times I struggled to keep the spiritual basis for the season in the forefront of my mind. It took intentional effort to keep Jesus above the commercialization.

Remember what's important, I told myself repeatedly when priorities started to get skewed. *Remember whose birthday we're celebrating.* It was around this time that the now-clichéd phrase, "Jesus is the reason for the season" came along. It struck a chord with me as I daily wrestled with this and focused on these words in Hebrews 12:2 about how we should be "fixing our eyes on Jesus, the pioneer and perfecter of faith. For the joy set before him he endured the cross, scorning its shame, and sat down at the right hand of the throne of God." I aimed to hold before me the reason Jesus came, and that was to die for my sin and the sins of the whole world.

Today, I no longer live my life between a mall and Seventh Avenue, but I often still struggle with keeping my priorities straight at Christmas. We can allow the good things in our lives to take over what is God's best. Even this past Christmas, after a week of two symphony chorus practices, two performances, and a children's program at church that I helped direct, I still didn't take a day off to rest as I had sensed God leading me to do. This set my tired immune system up for a fall, and it took me two months to recover.

So far, far away from those days on Seventh Avenue, I'm still challenged to remember the most important thing about getting ready for Christmas is putting Jesus above everything else.

One must be ruthlessly intentional to not allow the stuff of life to squeeze out the lively work of God's spirit in us and through us.

I'm regrouping for next year and believing for a better result.

Riding the Crescent

As the spinning steel wheels carried us closer and closer to our destination, the sun broke golden on our right, somewhere around Monroe, Virginia. I had never seen Virginia closer than 30,000 feet. (Well, once when I was two weeks old, but that didn't count.)

After dozens of trips flying into New York, I thought I would take the train, so I talked a colleague, Denise, into going with me. She had survived the elevator incident with me, so I thought she might be up for anything. I recently read an observation by legendary Georgia Writers Hall of Fame author, Celestine Sibley. She was a Hollywood correspondent for the *Atlanta Journal* in the 1950s when she booked a roomette on the Super Chief. She said, "On all previous trips to the West Coast I had flown, but it began to seem a waste to me—all the country I was passing over and not seeing."[25]

She summed up my thoughts exactly.

It had been an adventure.

We arrived the evening before at the train station in a neighboring town to catch the Amtrak Crescent, previously known as the Southern Crescent, which I remembered from my childhood. The Crescent route originated in New Orleans, then Birmingham, Atlanta, Charlotte, Washington DC, and finally New York, taking in dozens of little towns in between, including my hometown. A train had been running a version of this route for almost one hundred years.[26]

Upon arrival at the depot, I felt immediately as if I were in a Willie Nelson song.

The attendant at the depot had a master's degree in grumpiness and performed his duties as if he were afraid he might tell us something we actually needed to know.

"What do we do with our baggage?" We asked, peering through the smudged glass window. It seemed a basic enough question.

He ignored us.

As we continued to stand there, wondering if we would have to hold the suitcases in our lap all the way to New York, he nodded to his right.

As if on cue, through the door to the tracks, a stooped, elderly man dressed in a rumpled uniform came in and put tags on our baggage, and then without a word, proceeded to put them on the platform by the tracks. Oh, goodie. We got to sit and wonder for the next hour if they might be snatched.

Then we learned the train would be late.

Not especially good news, but it gave us plenty of time to notice the crowd assembling to board.

They headed to places both near and far. One family of a father and three elementary-age children entered, and I overheard him ask for three tickets to my hometown in Georgia, only about forty miles away. The shabbily dressed children were energetic enough, hopping, playing, and talking, but the father hardly had anything to say. He seemed dulled. I wondered about his story. I had a pretty good idea that it involved pain. Why only three tickets? They had to be for the children, but how could these wee ones travel alone? Would someone meet them on the train?

Being in a depot makes you ask questions.

In chairs opposite me, a young man, maybe twenty, wore a jacket that read, "Get into the music," and huddled close to a woman I assumed was his girlfriend. They were quiet. No music at all.

Maybe that shirt's slogan was for the next passenger, a character with an open collar shirt, navy suit, cowboy boots, and slicked-back blond hair who came in and immediately dropped

his luggage. I postulated that he would meet up with the rest of his country music group for a singing event.

A woman with overalls and an engineer's cap arrived, accompanied by a man sporting a tropical print jacket. I noted in my journal that their middle school son "looked regular," whatever that meant. An older woman with a young girl followed, headed to Connecticut.

A locomotive roared in, blowing the whistle I had known all my life, because I spent my first four years in a house less than a hundred yards from a train track. In fact, I have never lived anywhere except for a brief stint in college that I couldn't hear a train whistle. It sounds of consolation, and I've wondered if that's because my conception took place prior to my mother's return trip home from Chicago, where she had visited my dad in military service. As those cars chugged along through Middle America, my first cells were coming together in her womb.

We found our seats on the train and then headed for the dining car to eat. I didn't know stewards seated you randomly with other passengers in dining car booths. A Colonel Sanders look-alike, complete with bow tie, sat across from us, except instead of dressing in all white, he wore black.

"Why are you traveling by train?" he asked, interested in our reasons for choosing this mode of transportation. He followed up with questions about what we would be doing in New York, almost as if he were quizzing us and never allowing time for us to reciprocate with our own questions. As he listened, you would've thought we were the most interesting people in the world.

And the food—I still remember what I ordered that evening—vegetable lasagna. What was it about sipping on sweet tea while watching the lights of a dozen little towns whiz by out the window that made you feel you were seated across from Bing Crosby on that train to Vermont in *White Christmas*?

My friend and I returned to our seats around eleven, and we discussed our dinner companion. We decided he worked for

the train company and was doing research. As I glanced around the cabin, I kept slipping back into that Willie Nelson song. I hummed a little of "City of New Orleans" as I drifted off to sleep for a bit. Every time the train pulled into a station, I peeped out my window, afraid I would miss something along the way that I had never seen before. Like Celestine Sibley said, I didn't want to waste any of the country.

As that Virginia sun came up, in seats ahead of us, a group of Amish shared their breakfast of oranges and cookies with two little blond-haired children and their earth-hippie mother. So beautiful.

Soon, we'd change trains in Washington DC and get an express into New York. We'd encounter quite a different crowd on that leg of the journey—mostly business travelers on their daily commute. I pulled out my journal and wrote about our experiences over the past twelve hours.

In hardly any time, we whizzed into Pennsylvania Station.

As I stepped out of the station onto Seventh Avenue, the midday sun hitting my face, I tried to frame the cast of characters I'd met against the backdrop of where I was and what I did in the city. It was as if I had moved from one world to another.

I wondered about those three little children I'd seen at the depot, where they might be, and I prayed they were okay. I thought about the character who seemed destined for country music fame and if dressing for the job made you a success, I was sure things would go well for him. Our dinner companion on the train probably sat in an office right now making decisions about train travel based on his recent research. Glad we were of help. In a culture-clash victory, perhaps the Amish took guests home with them.

I asked again the question I often wrote in my journal, *Why was all of this happening to me?*

Most people ask this when bad things happen to them, but I just couldn't believe I had the opportunity to have these

incredible experiences to observe people and places—so beyond anything I thought I might ever do. I didn't know the answer to the question, but I knew that, as much as possible, I needed to keep a record of this life I had. I remembered what I had been taught in art school about seeing. There is quite a distinction between seeing a leaf and seeing the leaf. The same is true of people.

God definitely used these experiences to hone my people watching skills.

It would be a long time before I understood the significance of why.

Additionally, God was teaching me that He never wastes anything.

Eugene Peterson captured this thought well in his translation of the familiar Romans 8:28: "We can be so sure that every detail in our lives of love for God is worked into something good" (MSG).

Every detail.

So, if I believed that, I had to trust that all of this would be used for a greater purpose in God's time.

Today I know much of it has been.

My Literary Companions

A collection of dog-eared and tattered volumes line my book shelves, testament to the ten years I hauled them around in airplanes, taxis, airport shuttles, and trains. They bear coffee stains, rain spatters, illegible margin inkings, and the collective dust of a hundred hotel rooms.

They were my companions for all those years of travel, and I never left home without taking one or more of them with me.

Ralph Waldo Emerson said, "I cannot remember the books I've read any more than the meals I have eaten; even so, they have made me."

So, if I can remember a little, here's what I am made of. I'd like to believe and truly hope my life is Bible-focused more than anything else, but more about that later. I'd say next in line are works by C.S. Lewis and Oswald Chambers.

Lewis, through *Mere Christianity*, had a major influence over why I wound up in the shower that September night surrendering my whole life to God. He gave me hope that even my sin was atoned for on Calvary.

Over the years, after a day in the market, I would return to my hotel room, write orders for a while, and then make my way one by one, through *The Problem of Pain, The Screwtape Letters, Surprised by Joy* and other works by Lewis. They have been read and reread as I tried to absorb their truth to the core of my being.

As for Chambers, my first volume of *My Utmost for His Highest* sits bedraggled, coverless, and cracked, yet it's alive with the notes on its pages that recall hundreds of interactions where I sensed God speaking directly to me through the writings. I never

packed a suitcase in which this volume did not ride along, which accounts for its condition. Chambers daily sliced through whatever lies I might be telling myself and illumined God's truth for me in a way that few have ever done.

Sitting in the back of an airport shuttle, I read *Your God Is Too Small*, by J.B. Phillips—the man God brought back from the brink of death to render a fresh translation of the New Testament, which began while he sat out World War II in London's bomb shelters. He released the first of the translations, Colossians, just after the war with the help of his friend, C.S. Lewis[27] and future translations eventually culminated in the release of *The New Testament in Modern English*. Phillips taught me to step away from my narrow ideas of God and be open to who He really is. I was first introduced to Phillips by my dad, who used the Phillips translation in teaching his Sunday school lessons.

At the time, our store had a book department, and I remember studying the cover of one of Catherine Marshall's books. The cover seemed too much like a romance novel for me, and I passed on it. But on another examination, standing there in that second-floor alcove, customers milling around me, I got beyond the way the cover looked and read what it actually said. I bought it and loved it so much that I would read almost everything Marshall ever wrote—*Something More, Meeting God at Every Turn, The Helper, Beyond Ourselves, A Closer Walk*, and of course, *A Man Called Peter*. Marshall gave me a new understanding of the Holy Spirit's work in our lives. Her sweet novel about her mother's missionary work in Appalachia, *Christy*, became one of the few fiction titles I read for many years.

I waded through Dietrich Bonhoeffer's *Cost of Discipleship* and *Life Together*, which he wrote while teaching in an underground seminary during World War II. This man, who could have been a concert pianist and had an opportunity to escape the fray of his home country (Germany), went back willingly to stand against the Nazi regime and later died in a

concentration camp at the hands of executioners. Then and now, I often ask God to examine my life that I might not be guilty of what Bonhoeffer called "cheap grace."[28] Grace itself had been one of my biggest challenges to reckon with, and yet, I didn't want to go off the other end and forget that this grace cost Jesus His life.

With purchase order pads scattered around me, and the horns of angry cab drivers sounding through my hotel window, I cried over almost every page of Thomas à Kempis's fifteenth-century book on devotion, *The Imitation of Christ*. It was hard to read and hard to absorb and yet this voice came across the centuries, rising above the cacophony of my present-day life to bore into my soul.

I carted around commentaries by William Barclay and Charles Tyndale, searching for understanding, going through book after book of the Bible.

I read biographies of George Whitfield, John Wesley, George Mueller, D.L. Moody, Rees Howells, and Frances Ridley Harvergal, among many others. My friend, Jane, loaned me her copy of *The Hiding Place*, a biography of Corrie ten Boom written with John and Elizabeth Sherrill. I came near to having a heart attack when I opened its cover to see Corrie's signature. I almost gave it back, afraid I would lose it, but I am glad I didn't. Oh, how her story of sacrifice, heartache, and forgiveness touched me.

Hannah Whitall Smith's works, *The Christian's Secret of a Happy Life* and *The God of All Comfort* nourished and strengthened me. *Hinds' Feet on High Places* by Hannah Hurnard helped me face my fears head on.

More than once, I circled through study materials like Maxie Dunnam's *Workbook of Living Prayer*, and I have a vivid memory of studying Dr. Robert Tuttle's fine work on the Holy Spirit while taking a break outside the mall store one sunny afternoon.

I never, ever left home without my copy of *The Upper Room* magazine, which stayed inside my Bible at all times.

Those years are when I learned to lean into the Word of God. I went through two Bibles to broken backs, peeling covers, and loosened pages. In Psalm 119, we find two equally important Scriptures dealing with God's Word. First in verse 11: "I have hidden your word in my heart that I might not sin against you" and also in verse 89: "Your word, LORD, is eternal; it stands firm in the heavens." Because of these verses, I knew that no matter what other works I might be reading, the words written between the leather cover of my Bible had to take precedence and needed to be read more than anything else because they were eternal and would keep me from returning to how I had previously lived. In order for that to happen, I must have God's word residing in me.

After my shower experience, I began to read my Bible every morning. Initially, I did it on my knees. The pages of that particular Bible bear dimpled impressions from the many tears that fell on them. Though I had been in church for years, neither my actions or my heart resembled those of someone in a close relationship with God. Those tears expressed how vast the gap seemed between where I was at the time and where I believed God wanted to take me. I wept over my sins and seeming weakness, but I also wept at the beauty of God's tenderness and promised restoration.

Early on, I latched onto the interaction between Jesus and the woman in the seventh chapter of Luke. I'll never forget that morning before work when I first bent over those pages. Maybe I had read them before, but those verses seemed new to me. The story of how Jesus extended grace and forgiveness to this sinful woman dragged before him by the Pharisees overwhelmed me.

When Jesus asked them who loved more, the one forgiven little or the one forgiven much. The Pharisees had no option but to respond, the one forgiven much. "Therefore, I tell you, her many sins have been forgiven—as her great love has shown. But whoever has been forgiven little loves little" (Luke 7:47).

I had been forgiven much, and those tender words moved me more than I could say. I owed Jesus everything. Everything. And I wanted to love much.

Emerson said it—these books have made me. But THE Book has not only made me but kept me.

What could have been lonely nights spent in faraway hotel rooms became a sort of Bible college to me. Those distraction-free evenings provided a fertile place for me to learn, grow, and latch on to God's word. I met a woman during those years who thought I needed saving from what she saw as a cloistered existence. She did not know the Lord at the time and made vain attempts to free me from what she perceived as a boring life. What she couldn't understand is those seemingly dull evenings are what ultimately saved me. Those times I spent traveling gave me a foundation that has stood the test of time.

My husband, the theologian in the family, has taught on the Greek word sozo, which is often translated "save" or "saved." But though the English word may be the same in the many verses in which it is used, the meaning is not. Sozo does indeed mean salvation, but it also means healing and wholeness.[29]

I had experienced that salvation, which eternally alters one's trajectory, but the books that accompanied me helped bring healing and wholeness to my life. They helped me experience sozo for all eternity and in this life as well.

I continue to grow in my understanding of how God rebuilt my life during those evenings with Him, reading and studying His Word. I have concluded that God will at times allow us to get into secluded situations so that we may devote ourselves even more to him. What might appear to be a solitary way may often be a gift.

For sure, it was to me.

Downtown Cabby Drama

I stood on the curb near the corner of Seventh Avenue and Thirty-Fourth Street and stared at the multiple lines of streaming bumper-to-bumper traffic. Every cab's roof light indicated it was in use. The limousine we had ordered to take us to the airport failed to show, and here on Friday afternoon at 4:30, it seemed everyone in Manhattan surged toward the airport like shoppers to a 70 percent off sale. If I didn't get a cab soon, I'd miss my flight.

In New York, to participate in a corporate buy from that designer I referred to earlier who put little ponies on everything he made, two other buyers from Virginia and North Carolina joined me. We were laying down big money for our over 400 stores in the southeast.

The other two buyers knew each other, and from the beginning, I felt like the odd woman out.

We had to make decisions regarding style, sizing, and distribution according to store size. It would be nice to agree on these things, but clear to me at least, unless I agreed to what they had in mind, I faced an argument.

My favorite thing.

I mostly hated confrontation, but sometimes I found it unavoidable. I tried to save my disagreeing with these women for all but the most essential conflicts, because we had only days with a ticking clock to get it all done. In a few instances though, I had to stand my ground, because I didn't want to be the one responsible for sending merchandise into our stores that I thought

would wind up on the clearance rack, and cut into the store's and the buyer's profit. I tried to look after my own.

But my head hurt.

And my feet.

I had made the brilliant decision to wear a new pair of pumps. Don't ask why. I don't know. Because I was alone and because of the elevator fiasco at the other hotel, I went back to the hotel near Central Park. For ten years we ping-ponged between these two locations.

In this situation, though, I thought I'd be better off tromping through Time Square every day than trapped by myself in another elevator. Lots of walking. At least fifty blocks every day.

The blisters on the back of my heels equated roughly in size with the geographic area of the Sahara Desert and burned just as much.

Misery.

So here I stood, cab-forsaken with my bloody heels, and all I wanted to do was sit in a vehicle that would get me out of that place.

The last available taxi must have picked up their fare two days ago.

My colleagues seemed not to be that concerned, but I was. My funds were running low.

Now, this might be hard to believe, but in those days, we didn't travel with credit cards. We traveled with cash. I would have to estimate how much I needed on an expense account request and often left town with thousands of dollars in my purse. I tried to hone in on the dollar amount so as not to have any extra cash. I had made a decision not to have a personal card, because I didn't want any debt. So that meant if I didn't get a cab, I'd probably be sleeping in the airport that night. Happy thought. Additionally, I had no idea how I would get transportation in the middle of the night from the Atlanta airport to my home about sixty miles away. Today airport shuttles to my town run dozens of times a

day; back then they only ran a few times a day. If you missed them. Too bad.

Despair started to set in, so I did what we do when at the end of our rope—my heart cried in prayer, Lord, you know my situation. Please send us a cab.

Seconds later, a cab pulled up and dropped off a fare. Why, I don't know—because every showroom in the garment district seemed to have closed its doors for the weekend. When that cab door opened, we barely let the man in it exit before we grabbed it, and packed in.

"Can we make it to LaGuardia by 5:30?" I asked the driver, feeling a little frantic.

He turned in his seat, shook his head, and waved at the traffic. "You see this?"

I saw it. "But can you try?"

Still shaking his head, he put the cab in gear and took off.

Did I mention he took off? Literally, as in jet-propelled engine, took off.

Now, here's a strange thing. For all the years I traveled to New York, I'd get in a cab after landing at LaGuardia and feel in a bubble. On more than one occasion, our driver would exhibit some form of crazy, but it never bothered me. Ever. I remember others I traveled with would turn white, shake, and generally appear as if they might pass out because of the erratic driving. All of that seemed to have nothing to do with me. I'd just be like, "Oh, doesn't the Hudson look pretty in the sunset?" Maybe I was so relieved to be out of the airplane, nothing else bothered me.

Good thing I had that bubble thing going on that day, because practically speaking, the possibility of getting sandwiched between two other yellow hunks of metal as he wove in and out of traffic in the wildest possible way was a real possibility.

I have to hand it to him. He got us there minutes before my plane was about to leave.

The question at that point—how far to the gate? If I had to cross the length of the airport, I'd miss it for sure.

In that pre-9/11 world I threw my luggage at the curbside check-in, clutched my briefcase under my arm and my raincoat in the other, and flew, grimacing and limping all the way. My gate turned out to be the first one in the terminal. The flight attendant had her hand on the aircraft door to close it when I stepped through the portal.

"That was close," she said.

"You have no idea," I said wincing.

Now, here's where it gets interesting.

The next day, I received a call from Sandy, a church friend. We had become close after I moved to town several years before. She, a mother of two young children, and I, a career woman, would seem to have nothing in common. However, when we met together after choir practice every week, it's as if the rest of the world fell away. We shared deep spiritual things, and often prayed for each other.

"I'm so glad you're back," she said after we exchanged hellos.

"I am, too," I responded without elaborating.

"I wanted to talk to you yesterday afternoon, but I knew you were in New York." Evidently, a now-forgotten circumstance had arisen, and she needed a sounding board. She went on. "It was such an intense feeling. I just lay across my bed and prayed, 'Lord, send Beverly back. Lord, send Beverly back.' "

Could it be? "What time was that?" I asked her.

"Oh, it was around 4:30," Sandy explained.

4:30, the exact time I stood on the street corner praying for a cab.

I told Sandy what had happened. Without even realizing it, she had been agreeing with me in prayer.

The phone grew quiet on the other end, and I realized she was crying.

At that time, Sandy often felt left out of what happened beyond the four walls of her home. As a stay-at-home mom, it seemed to her opportunities to be involved were limited.

I told her, "I believe your prayers are the reason that cab pulled up when it did. If it hadn't, I would have been stuck in that airport for hours until maybe a redeye opened up in the wee hours of the morning."

For Sandy, the fact she prayed for me at the exact time I needed, strengthened her understanding of her important role in prayer.

For me, God reiterated those verses in 1 Peter 3:12: "The eyes of the Lord are on the righteous and his ears are attentive to their prayer." I knew Sandy and I weren't righteous of our own doing but because of the righteousness that Jesus had imparted to us. Because of Jesus, God heard our prayers—not because we deserved it but simply out of His love for us. God doesn't always answer prayers the way we want. I may never in this life understand outcomes I've experienced at other times, but that Friday afternoon was truly remarkable.

Years later, our roles reversed. Sandy returned to graduate school and become an educator who received many accolades in her field. God used my experience on that street corner in another way. Then, as a stay-at-home mom myself, God had already shown me that He could use me in ways I couldn't imagine through prayer, even though I wasn't out in the world as I had been for so many years.

In every season of our lives, God sees us.

It's especially good to know on a Seventh Avenue street corner when you're waiting for a cab on Friday afternoon.

For the Love of Cheesecake and Tourist Traps

I stepped up to the counter at Harry's Deli and studied the offerings in the glass front case. "One whole plain cheesecake, please."

The clerk nodded, pulled out a round cylinder of goodness, and placed it in a cardboard box. When she gave it to me, I held it close. No one had better bump into me with this precious cargo in tow. I wouldn't even place it in an overhead compartment on the plane. I would gently put it under the seat in front of me so no one else's stuff could crush it. If I could, I would have put a seat belt around it.

I had never had cheesecake before I traveled to New York.

Now, I had something we called cheesecake—a sort of graham cracker crust thing that we made from a box. It had a pudding-type consistency, and I thought it was just fine until I met real cheesecake.

My uneducated palate, again.

New York cheesecake stands high and firm with coffee. It draws you in with its umpteen thousand delicious fat calories and holds you captive. After I discovered what I had been missing, on every trip North, I usually carried one back to Georgia with me. Cheesecakes are heavy and remind me of a quote from Miss Piggy—something about not consuming more than you can pick up. Sage advice, but I managed just fine.

I couldn't remember the name of the coffee shop where we had cheesecake after a show, but all I did was put "cheesecake,

New York, seventh avenue" into a search engine, and Lindy's came up as the first result. Their widely celebrated cheesecake had been immortalized in the play *Guys and Dolls*, in which two of the actors praised its merits.[30] Some think that at one time Lindy's cheesecake may have been the most famous in the country.[31] My colleagues and I spent many a late night at one of their shops next door to our hotel on Fifty-Second. There we savored the dense goodness of a variety of cheesecake flavors. It was another incarnation of the original Lindy's but still, I loved it.

I usually lost five pounds from all the walking I did on New York trips, so it didn't matter about all that cheesecake. It matters now. Cheesecake and I see each other very infrequently these days.

While rifling through memorabilia from ten years of travel, I found a menu from Mama Leone's, located in the theatre district over on Forty-Eighth Street.

"A tourist trap," Jean had said when I suggested it on my first trip to the city. Jean's highbrow tastes in food and culture rising up again. Although, I had twelve inches in stature over her, she routinely looked down on my unrefined dining choices.

"But I heard they have violinists and singers who stroll around and serenade you," I objected.

She raised an eyebrow, but out of deference to my newbie status, she went.

Here at Mama Leone's, Will Rogers had sauntered in one evening in the 1920s and enjoyed roast spring chicken.[32] Apparently, his tastes ran in the same direction as mine.

I loved it. The food tasted heavenly, and the musicians charmed us all. I think even Jean enjoyed her experience.

It was the first time I saw the word antipasti on a menu.

"What is that?" I quizzed Jean.

She stared at me as if I had grown another head and sighed. She endured a lot from me.

Speaking of restaurants and music, The Asti down in Greenwich Village employed professional opera singers as wait staff who might spontaneously erupt into an aria or two.[33] Photographs of notable figures who had visited lined the walls—Babe Ruth, Nöel Coward, and opera singers that included Enrico Caruso and Luciano Pavarotti.

Sadly, after many decades of doing business, both these establishments closed but still often show up in lists of New York's most iconic restaurants. I am glad I had the opportunity to eat at both of them during their height of popularity.

At the Russian Tea Room[34] located next to Carnegie Hall, I had chicken Kiev for the first time in my life. Members of the Russian Imperial Ballet founded the restaurant over ninety years before, and even today, it continues to delight with both its food and decor. We didn't go often because the prices topped our expense account allowance, and we were into our own pockets even with their more modest offerings. It was worth it.

So many things I enjoy now, I experienced for the first time in the city. When I veered off my usual chicken route and ordered coconut shrimp for the first time at a steak house on Seventh Avenue, I almost fainted when I took my first bite. So good. I forget the name of the restaurant, but I will never forget the coconut shrimp and have searched a lifetime to find any that compare with how good I remember them to be. So far, no deal.

The second time we visited a restaurant off the beaten path, something seemed a little strange. One of our group had found the place and decided it looked good, and the first time we ate there, it did seem okay. On this visit, the air had a film noir feeling—too many people apparently working there but not involved in food service. Too few patrons. Can you say creepy? It made me want to keep an eye on the back booth and watch out for unexplained bulges under jackets. I don't know if anyone else in our contingency ever went back, but I didn't. Sure that one evening someone was bound to stumble in from a *Godfather* movie, I cut

a wide berth around the place in the future. They were a front, and I didn't even want to know for what.

After working all morning on Seventh Avenue, one of my favorite places to stop and eat besides Harry's was Macy's lunch counter. I'd stroll up to Sixth and take one of the clickety clack escalators up to a stool at the counter that seemed reserved just for me. The whole place had a black and white feel, and I found it consoling to perch on that bar stool while waiting for my meatloaf and mashed potatoes to be served.

When I look back over those years, I see a long line of quaint places where we met and shared our lives over a meal. In my town now, we have a few places like that, and whenever I visit, I have a flashback to those years.

The psalmist wrote, "Taste and see that the LORD is good" (Psalm 34:8). The incredible dining experiences I had also paralleled and punctuated the spiritual journey I had been on trying to understand God's overwhelming goodness to me. It is important to have that understanding ingrained in us, because otherwise in our humanity, when tough times come, (and they will come) we'll begin to question if God loves us. I had tasted, and God was good. In years ahead, I would return again and again to that truth so that I might rest in it. In fact, one particularly challenging season of my life directly connects to one of my New York dining experiences.

I couldn't have known it then, but that particular restaurant would become the center of an event that is etched not only in my memory but also in the memory of every American living at the time. In light of those circumstances, I would need to remember that God is indeed good.

Windows on the World

One November evening very early in my years traveling to New York, my colleagues and I piled into a yellow cab after spending the day trolling the markets on Seventh and Broadway. We were ready for a great dinner. "Where to?" the driver asked.

We exchanged glances. His accent indicated he was from the outer boroughs—native New Yorker and possibly a jackpot of information. "Where should we eat dinner tonight?" someone ventured.

Without hesitation he declared, *"Windows on the World—World Trade Center"* And off we went.

The World Trade Center, which would become a cluster of buildings, included the twin towers, the tallest buildings in the world. They had opened a few years before in 1973. Windows on the World was apparently in the North Tower.

As the driver went on about how it was one of the highest revenue producing restaurants in the country, and other details, which I can't remember, he left out one pertinent fact until he dropped us off.

He announced it as he stopped for us to get out. "One hundred and sixth and one hundred and seventh floors."

My legs went gelatin.

In my naiveté, I had no idea the restaurant was on the top floors. I didn't want to go to the one hundred and sixth and one hundred and seventh floors, much less eat up there. I prayed as I wobbled out of the taxi anyway, determined not to let my fear overcome me.

When getting into an elevator headed for a high floor, as always, I found it comforting to take a local, stopping occasionally on the way. Not the crowd I was with. Express all the way.

So we entered the elevator, pressed the button, and whoosh, we were gone. I tried to think of my favorite things, but showers and flowers didn't seem to cut it right then. About the seventieth floor, it felt like the elevator bashed against the shaft. About the ninetieth, I was sure it did.

When at last the doors opened, I clutched the side of the elevator doors, staggered out, and tried to stand. Instead, I swayed, because shockingly that's what the building did, architecturally constructed to move with air currents.

The restaurant spilled in front of us in levels to a bank of windows, which opened onto the Manhattan skyline, therefore the name Windows on the World. A stunning sight once I recovered from the teetering.

The maître d' seated us right next to the windows. I had to ask myself how I ever got here as I took in the scope of the city around me. In fact, if you want my view that night, rent *Sleepless in Seattle* and fast forward to the part where Meg Ryan's character dines with her fiancé right before she dumps him to go meet Tom Hanks's character at the top of the Empire State Building. They are seated in Windows on the World almost exactly where I was.

I ordered chicken. I know this because my sister would receive a postcard from me with a picture of the World Trade Centers, and on it I had drawn a line to the top of the North Tower and written, "I ate chicken here."

Then as we ate our overpriced poultry, it began to snow. C.S. Lewis titled his spiritual journey, *Surprised by Joy*, and I often found that to be true in those early days of walking with God. Joy at such beauty. It was as if I were living in a snow globe that evening.

Back in my hotel room that night, on the stationary of the New York Statler Hotel, I'd scribble a note, "Snowflakes and chicken at 1,070 feet off the ground." Just so I wouldn't forget (as if I ever could).

I'd also write what I was only beginning to learn. Every day in this new spiritual journey meant praying and submitting to God's will. Painful progress. At each point of sacrifice, it seemed so large, and then in hindsight so, so small. Just as I reluctantly entered that World Trade Center elevator that night, I often resisted the new thing God called me to, the high places he wanted to take me. I learned that if I held back, I might miss something incredible. So, I had to face fear, embrace change, and die to myself.

Part of a prayer I wrote around that time went, "Forgive my sins, my excuses, and my seeming logic. May I continually die to myself and continually live for You. Grant me wisdom to choose Your will and the strength to carry it out." I knew the God who gave me life would give me courage to live it.

On September 11, 2001, we had just received news a few days earlier that my mother was terminally ill. I fed her breakfast and then I noticed the clock—8:45. I had to go home from the rehab center where she was so my husband could leave for work and I could start homeschool with my two children. In the few minutes it took me to drive home, I didn't realize our world changed forever. Back in our schoolroom, I took the apple with the eleven stamped on it and placed it on our calendar. A few minutes later, the phone rang. The caller identification indicated another homeschooling mom. Remember Denise of "The Elevator Incident" and "Riding the Crescent"? Well, our newest adventure was homeschooling our kids. Definitely the most challenging of all our exploits. Homeschool moms don't call each other during instruction time, so I knew it must be important. I answered.

She told me the news of two jets hitting the twin towers of the World Trade Center. It was so unbelievable, I said nothing, and

when my children worked alone, I excused myself to go upstairs and turn on the radio. I heard the news on the radio but wanting to think it might be an Orson Wells "War of the Worlds"-type scenario I then went to the television in the den. There I saw the shocking pictures. As I watched, the Pentagon disaster also unfolded.

I stared at a mass of rubble on a television screen and tried to process the unthinkable. The crystalline moments of wonder that evening many years before flashed into my mind and contrasted sharply with the tragedy before me. All the people eating breakfast in the restaurant where I had eaten one amazing evening perished in the disaster. The fact that I had sat in those very seats made the loss personal to me. I dug out an old post card of the towers I had left over from that time and placed it on a table I passed several times a day as a prayer reminder for all of those whose loss was more than I could imagine.

The grief over my mother (she would die a few weeks later) and the many deaths of September 11 intertwined for me. A hospice chaplain I spoke with at the time said everyone he worked with experienced the same thing.

Who could have seen that snow globe evening that the very seat where I was sitting would become the epicenter of such a disaster? Who could have known the matchbox I absentmindedly picked up as we left would one day evoke such conflicting emotions as I came across it again in a box of memorabilia?

Life is full of contrasts, but none in my life has been more profound than my experiences involving Windows on the World. When a beloved pastor and his wife moved to another town, this verse held me fast after his departure: "Jesus Christ is the same yesterday and today and forever" (Hebrews 13:8). In times of unimaginable tragedy and cataclysmic shifts, it's good to know there is a God who never changes, who is always the same.

The snow globe moments don't last forever, but God does.

The time I spent at the top of the World Trade Center was a gift. I refuse to let what has happened since steal all the joy I had that evening, because if I do, the terrorists' work continues.

I pray I would allow God to shape my window on the world to be one of hope and thanksgiving, and that I would ever be watchful for the next thing He will do.

Mervin

Through the years, I bought or supervised the purchasing of almost every women's line you can think of in juniors, misses sportswear, and dresses from moderate to designer, budget, large sizes, petites, accessories, lingerie, cosmetics, swimwear, bridal, and even maternity. In my final position as a divisional merchandise manager, I made budgets for over 150 departments, which accounted for many millions of dollars in both sales and inventory.

This meant dealing with sales representatives. Lots and lots of sales representatives.

They came in every shape, size, and temperament.

I've had sales reps lie to me, hit on me, talk down to me, and more than one tried to bully me—all to little effect, I might add.

I dreaded seeing some of their names on an appointment calendar. With others, I genuinely anticipated an encounter.

Of all the hundreds of sales reps I worked with, one name stands out above the others—Mervin.

He repped a traditional line of upscale women's sportswear, one of the bread-and-butter resources for our company, so there was never the question of if I would buy from this vendor, but rather how much I would spend depending on the strength of the line that season.

Mervin never questioned my judgment or tried to get me to up my order. In fact, I trusted him so implicitly, that if I found myself in a time bind, I could give him a dollar amount, and count on him to pick the best styles for my location. Sometimes better than I could.

This alone is not what made Mervin memorable. I can't tell you when this started, but after Mervin and I finished reviewing the line and the ordering process, he'd zip up his samples and sit down in a chair on the other side of my desk. Then we'd talk.

"I caught myself praying in the shower the other day," he said, "and wondered what my Rabbi might say about it."

"I pray in the shower all the time," I responded.

Yes, he was Jewish.

Mostly we talked about what God was doing in our lives. Reverent, in notes to me, he spelled God, G-D.

We'd spend thirty minutes or so discussing the differences or similarities in our faith. Decades older than me, the age difference did not hamper our communication. Then almost always, he ended our conversations the same way. "Beverly," he said with conviction as he gestured to me, "You know you have a calling. This job is a great opportunity for you, but you won't be here long."

I knew Mervin meant God had other plans for me beyond working in the fashion industry and that they would have to do with my faith. He proclaimed this almost every time we worked together.

It felt as if an Old Testament prophet had risen up and pointed a finger at me. I could hear in my spirit the words of Jeremiah: " 'For I know the plans I have for you,' declares the Lord, 'plans to prosper you and not to harm you, plans to give you hope and a future' " (Jeremiah 29:11).

I knew I had a calling, too, but at the time I remained clueless as to what that calling entailed. So, meanwhile, I would continue as I was, but Mervin's words helped me believe that God did indeed have something else vocationally for me on the horizon.

I had not heard from Mervin in years, so while writing this book, I decided to search for him. The first result was an obituary from many years ago, which saddened my heart. No wonder there had been no contact.

I don't know who wrote the piece, but it captured him perfectly. "Mervin's long and prestigious career in the apparel business was marked by the kindness and respect he showed every person with whom he dealt. Throughout his life, Mervin never met a stranger and was loved by everyone who had the privilege of meeting him."

I did love Mervin. . .for all the reasons named above, but especially because he was able to see my future even before I was able to see it.

My daughter has in her closet a double-breasted navy blazer I bought off Mervin's sample rack many years ago. She still wears it occasionally and when I see her in it, I remember the prophetic word of one of the most memorable people I've ever known and how knowing him helped shape my life.

"You will not always do this," Mervin proclaimed.

Mervin was right.

Why I Left

In a yet-to-be-completed novel manuscript on my computer, the protagonist, Margaret Johnson, had much the same job I had. I don't know if I will ever finish that story, but the beginning of it illustrates the way I felt about my career:

"Margaret Johnson knew about stores.

She knew stores were places of beginnings—first shoes, first bras, first prom dresses. She had watched a young woman full of baby and expectations choose tiny pastel garments to cover her soon-to-appear offspring. She had helped a bride-to-be search through frothy dresses from glass-cased offerings in the bridal salon and seen her eyes twinkle when she discovered the one of her dreams.

Margaret Johnson knew stores were also about endings— a man stumbling through the front doors, blind with grief and bound to choose the prettiest dress he could find—the last thing his wife would ever wear. She had seen the middle-aged couple too numb from their loss in a tragic accident to know what they were doing, speaking as if they were choosing a suit for their beloved son to wear to a school dance.

Margaret Johnson knew stores were also about everything in between—hospital gowns, basketball shoes, swimsuits. They helped people go to Hawaii, serve dinner, walk a marathon, dance a Rumba, work in factories, and spend the night at the Ritz.

Margaret Johnson knew stores were not just buildings and merchandise and cash registers. They were living places where lives bumped into one another, each of them carrying away a piece of the other along with their purchases.

Margaret Johnson knew all of this because Margaret Johnson worked in a store. Maybe worked was not the right word, maybe the right word was lived, for it often seemed that the place she spent the night every night was not home, but home seemed more like the place she spent the day."

I could write this not because of research I had done but because of the life I had lived.

To this day, I cannot join those who throng to "Going Out of Business" sales, because for me, they are like a wake—the bare shelves, the sad-faced employees, the last markdowns on merchandise bought with the highest expectations. The closing of a store means someone, and usually many someones, are having to let their dream slip away.

No matter how many times I see Nora Ephron's film, *You've Got Mail*, I choke up when Meg Ryan's character closes for the last time the door of the bookshop her mother had opened forty-two years before. Remember the sign on the door talks about how after all those decades, they were shuttering their store, but their joy had been being involved with their customers? She walks off down the street, the bell from the shop door tinkling in her hand, a tiny death knell of sorts.

Stores to me are living, breathing things. The minute the key is turned in the lock and the door opens for others to come in, who knows what will happen?

I, myself, marked years of my life ascending and descending escalators, greeting customers, making budgets, merchandising four-ways, formulating advertising plans, listening to complaints. Sometimes, it did feel as if I lived there when I was not traveling. For those years, though, that was all right with me. It was my home base, my touch point, the place where I belonged.

So why would I ever leave?

After I'd been with the company about eight years, I was promoted again—this time to a divisional merchandise manager position where I supervised six other buyers. I wouldn't be on

the front edge dealing with purchasing but rather writing and managing budgets, trying to keep our purchasing under control and working hard to reach sales projections. I'd still travel and accompany buyers on most of the trips. Additionally, I would be responsible for the management training program, which meant training new hires headed into the purchasing positions in our group of stores. Excited for the opportunity, yet I knew the job ahead would be a lot about solving problems. Lots of problems.

In my tenth year with the company, I began to have a certain unease. I still liked what I did, but the waters seemed to be stirring—nothing in particular, but I kept thinking about what Mervin had said.

I also pondered verses God had given me about six years earlier, indicating that at some point in my life I would be involved in a ministry to orphans. I had no idea what that might mean, but after praying for years, I seemed no closer to the realization of what those verses meant.

Meanwhile, that attorney, Jerry, who I traveled with to Colorado wound up following a call to ministry. He left his law practice and went to seminary, then took a small church appointment while finishing his education. We had prayerfully continued our relationship, trying to work through emotional baggage we had been carrying around. About the same time I received that last promotion, we married and I took on the role of a pastor's wife.

We had become involved in the past year with a local ministry that provided alternatives to abortion for women in crisis pregnancy. We had two women who needed housing live with us for several weeks. Jerry was on the board of this ministry, and one day he came home and announced they were looking to hire a full-time director. Up to that point, volunteers had managed the ministry.

As soon as the words left his mouth, something in my heart moved. I went back to the original Scriptures God had given me all those years ago.

A father to the fatherless, a defender of widows, is God in his holy dwelling. God sets the lonely in families, he leads out the prisoners with singing (Psalm 68:5–6).

But you, God, see trouble the trouble of the afflicted; you consider their grief and take it in hand. The victims commit themselves to you; you are the helper of the fatherless (Psalm 10:14).

I knew I was supposed to apply for this job. I explain why in these excerpts from my application letter:

The baby in peril of abortion has no earthly parent to stand up in its defense. God would call us to take the place of that earthly parent to offer an alternative. . . The victim commits himself to God, and God has sent us to respond.

I went on to talk about my current job.

I work for a company that has been good to me, and I have appreciated the positions I have held. It is not easy to say good-bye to a career that I have enjoyed; there are those miserable in their work—I have not been one of those. There is the practical side of losing insurance, discounts, profit-sharing, and a decrease in salary. But above this financial side, and leaving a career I enjoy, the most difficult thing is leaving all these people. I have loved them. . .such a big part of my life."

I concluded with these words:

But God has spoken to me about this also. I love what I can see and touch and hear, but He calls me to love the ones I cannot see or touch or hear. He calls me to love as He loves the host of those that will lose their lives this year unless someone reaches these mothers with an alternative. I am moved by the words of Oswald Chambers: 'God sometimes allows you to get into a place of testing where your own welfare would be the right and proper thing to consider if you were not living a life of faith; but if you are, you will joyfully waive your right and leave God to choose for you.' [35]

I concluded with saying I was willing to be obedient and let God choose for me.

There was hardly any reason they should have hired me. Though my husband was on the board, he in no way participated in the decision process.

In the end, they offered me the job.

I accepted.

When I left Franklin's, I was not running from something, but running to something.

I remember my last day. I had been blessed with a wonderful going away party, and when I walked out the employee entrance, the sun descended to the horizon shining directly into my eyes. I hit the bar across the door, and walked through it. As I heard it close behind me, I knew the door had closed on this chapter of my life, as well.

Faith in the Fashion District

The waiter brought my baked chicken and placed it in front of me. I scanned the group of colleagues around the table, then as usual bowed my head to say silent grace. When I looked up, every person at the table had also bowed their heads and waited for me to say my prayer before they began eating. Tears welled at this tender scene.

So, after many years, that's what happened with the small beginning I had of saying grace before meals. Each of these people became my friends, not just colleagues, and had come along with me in some measure.

I remember often thinking that I shared more meals with co-workers than with my own family. At the time, I wrestled with that. Now I know those shared hours around a table provided a basis for lifelong relationships, each of them I treasure. In many ways, these folks became family.

When I reread my journals from that ten-year period of my life, I came across names on my prayer list I didn't recognize, people I encountered in my journeys who voiced a concern, or maybe my heart was just burdened for them.

Some I would never forget. I am so aware that these opportunities I had for ministry had everything to do with God, and I am humbled that He could in any way use this broken vessel for his glory.

One of my favorite poems by Samuel Shoemaker, "I Stand by the Door," tells of a desire to help those just coming into the faith. I connect this to the verse in Psalm 84:10, which reads: "I would rather be a doorkeeper in the house of my God than dwell in the

tents of the wicked." I have seen myself in that doorkeeper role to some degree, so I wanted to help others out there who might be conflicted as I was then, wondering if God can use you right where you are. Let me tell you that unless you're selling crack, he can. And he will, if you open your heart and spirit to His working. Because, no matter where you are, God is always at work.

The first person I ever prayed with to accept Christ was a woman I'll call Alicia. While she was in college, she worked in the accessories area of our store. One day she found out my then boyfriend, Jerry, was sharing his testimony in a nearby church. She asked me if she could come.

"Sure," I said. "I'll meet you there."

That morning after he had given his testimony, he stepped to the altar of the church to pray with those who came forward for ministry. I had a strong impression that I should speak to Alicia, so I turned to her, "Do you want to accept Jesus as your Savior?"

"Yes, I do," she said and almost scared me to death. What did I do now?

We went to the altar. I kept looking for Jerry to come over, but he didn't. So I prayed the best prayer I could come up with, and somehow it took.

Decades later, she and I still see each other occasionally even though she lives in another area of the country. She means so much to me.

On another occasion, a single mom at the end of her rope who worked in our store sought peace, and I had the joy of seeing her also come to Christ, which made a difference not only in her life, but in the lives of her children.

My assistant found her way to our church one Sunday morning and almost ran to the altar to accept the Lord. We learned weeks later, during a routine doctor's visit, that she had cancer. She died a short time later, but we knew she was with Jesus.

A sales rep shared his devastation over not being able to join his synagogue because he couldn't come up with the $5,000

donation required to join. I went back to my hotel room that night and wrote out the entirety of Isaiah 55, which begins, "Come, all you who are thirsty, come to the waters; and you who have no money, come, buy and eat! Come; buy wine and milk without money and without cost. Why spend money on what is not bread, and your labor on what does not satisfy? Listen, listen to me, and eat what is good, and you will delight in the richest of fare" (verses 1–2).

When I delivered it to him the next day, he looked up from the passage with tears in his eyes. "You wrote this out for me?" he asked.

I nodded. I just wanted him to know that God doesn't charge for a relationship with him, because Jesus has already paid that price.

I also shared that good news with a rep who expressed his terror at the thought of dying. "You don't have to be," I told him and shared the gospel.

Another rep often called me to pray for his critically ill sister.

Another, after we had several conversations, began attending church again, and even brought an atheist friend with him.

I was able to pray with several other associates to accept the Lord. Some I still see, others for one reason or another, we have lost touch. I'd love to sit down with all of them and see what's going on in their lives. I miss them. If you're out there and reading this, hey, let's get together.

My philosophy during this time in my life was to speak to others as if they already understood what I was talking about spiritually. That way there was none of this "I know something you don't know business."

Folks would just go along with it until they couldn't anymore. Then I'd have the privilege of telling them about what Jesus had done for me and for them.

One late night, I had operation responsibilities to close the store. I got into a conversation with one of our security personnel and made the statement that we can't earn our way into heaven.

He looked at me stunned. "You're scaring me," he said. Evidently, the thought of not being able to fill up his good deeds list in heaven disturbed him greatly. If we could have reached heaven that way, Jesus would never have had to come.

And that's when I told him what the apostle Paul said, "For it is by grace you have been saved, through faith—and this is not from yourselves, it is the gift of God—not by works, so that no one can boast" (Ephesians 2:8–9).

He said he had never heard that before.

Well, I knew a little bit about that grace. I had the wonderful honor of sharing about God's amazing unmerited favor, a subject that God had instructed me in repeatedly over the years.

All of these experiences and so many more did in fact turn out to be the foundation upon which God launched a lifetime in ministry.

Restart

Oswald chambers wrote:

> God has ventured all in Jesus Christ to save us, now He
> wants us to venture our all in abandoned confidence in Him.
> There are spots where that faith has not worked in us as yet,
> places untouched by the life of God. . . 'This is life eternal, that
> they might know Thee.' The real meaning of eternal life is a
> life that can face anything it has to face without wavering. If
> we take this view, life becomes one great romance, a glorious
> opportunity for seeing marvelous things all the time. God is
> disciplining us to get us into that central place of power.[36]

I etched these words into my journal early on in my travels,
before another trip to New York. " 'Abandoned confidence' is
what I pray for," I noted.

When my computer goes haywire, I almost always select re-
start. That usually rectifies any technological craziness. Long be-
fore my laptop became like another appendage to me, I, myself,
went through a major restart and found it challenging on every
front.

Before I started to work for Franklin's, my life had gone
off the rails by things done to me in addition to choices I had
made. I had this perception that I would just slide into the home
plate of heaven, God would slap me on the back, chuckle at all
my little antics and things would be swell. I never stopped to
think that if sin weren't so deadly, Jesus would not have had to
die for it. Again, I did not understand grace—what it meant or
how it applied to my life. I was stuck in the idea that we earned

forgiveness by being a good person just like that man who worked in security.

I had no idea our works had nothing to do with earning salvation. I also did not know the difference between happiness and joy. Happiness depends on what happens to you and my life had been an emotional roller coaster. I had not experienced the joy that comes through surrendering our lives to the power of His Holy Spirit, so that even in the middle of personal suffering, we may have a spring welling up inside of us that transcends human happiness.

God in his mercy gave me a restart. Just a year after starting to work for Franklin's, I surrendered my life wholly to God, broke off an unhealthy relationship, moved to a new town, began to attend a new church, and tried to establish a new pattern for living.

The foundation of that pattern rested in discipline. Just as a child may experience lasting security because his parents care enough to set boundaries, God's children experience more freedom when they allow God to bring discipline in their lives.

Discipline may look different for each of us, but for me, it meant time in God's presence. I posted almost daily in my journal about my walk with God, kept a list of prayer concerns and Scriptures that spoke to me, and special notes about my trips or prayers for colleagues. I also kept a running gratitude list, because I was learning to offer praise despite difficulties since praise alters our perception of circumstances. In time, I realized it turned my heart from the problems to God. This is when I established a morning time with God. I wrote, "I am aware of change in me, like being remade. Getting up early is a struggle, but I am doing it for Him. I get up, fall asleep, wake up again. Breaking old habits."

In other matters of discipline, I tried to be faithful to witness to my faith, serve in the church, volunteer in a way where I would not receive recognition, and big one here—learn to walk by faith, not feeling.

Restart.

I'm an artist at heart, so I had tended to go the way of the senses—the love is a feeling thing. I could no longer let my life be solely guided by whatever wind blew at the time, but it had to be steered by God and His Word. Love could be a feeling, but more often, it required action.

Another restart for me involved getting over that myth that we do this and that and everything will smooth out. The road is never completely straight and smooth. Ever. There's always another bump or bend, but I learned God is with us to navigate. "In this world you will have trouble," Jesus said (John 16:33). And we sure do. Sometimes even more so when we give ourselves totally to God. Surrendering our lives to the Lord puts us in the enemy's crosshairs. But the rest of John 16:33 reads: "But take, heart! I have overcome the world."

I experienced the pain of regret over years of poor choices. The consequences of those choices could not be erased, because once those seeds had been planted, they continued to bear a harvest. But in time and in God's grace, those bad seeds could play out, and a new and good harvest began to come in.

Alongside these challenges, I also began to see "marvelous things all the time," the concept Chambers writes about—that "great romance" with Him.[38]

As I shared before, I wrote songs in anonymity after my surrender to God, but when I took the risk to share them, interesting things happened. All of them scary to me. Ever aware of my sinful choices, the enemy delighted in throwing shame on me, but when I dared to step out, I could hardly imagine what God did.

One evening after experiencing that same old sense of weakness and unworthiness after singing at a women's event. I came home and wrote, "It hurts to take your heart and put it on display so others might remark about it." But the next morning I found nineteen women had given their lives to the Lord that evening. I realized once more, we can't judge results based on how

we feel about things, but we must continue to be faithful in our availability.

On that New York trip I mentioned earlier, my colleagues and I loaded into a cab and found the driver to be the most belligerent we'd ever experienced. Anger seethed in him. That evening, after planning my schedule for the next day, I turned to my journal and penned the cab driver down as a prayer request, annoyed with myself that I had not made more of an effort to witness to the man. I continued to have times when I thought I had failed God and other times I sensed that maybe I had done what I should, but in success or failure, I learned I could turn to God to put my life on the right course.

I wrote one evening, "When the struggle is hard, I know 'we are more than conquerors through him.' The enemy would have us focus on our guilt, our fear, our pain, but by the redeeming, making-all-things-new love of Jesus, we need never be prisoners again of the enemy's lies. In a crowded room or my own closet, the knowledge that He cared enough to send His son to die so that I might live brings me to praise. In any pain I know now, Jesus dying for me is more than enough."

What's more, I knew it always would be—no matter how many restarts I went through.

A Lifetime of Ministry

So what has that lifetime of ministry looked like?

I am no famous person, and although my husband was somewhat famous (at least here in the South, having played college football on a Southeastern Championship team as well as having been an attorney with a prestigious law firm for years), still after he went into the ministry, we have lead fairly quiet lives. What we have tried to do is be faithful rather than famous. Our lives have been small but I hope valuable.

I shared earlier that I live in a university town. A very large university.

For years I had regularly been on campus as a guest speaker in fashion merchandising classes. Now as director of the crisis pregnancy center, I was to work with that same age demographic as some faced what was perhaps the most challenging crisis of their lives—an unplanned pregnancy.

Almost every woman I have ever known has been interested in how I made my living in fashion for those ten years, everyone from mathematicians to hairstylists. Immediately my vocational history was of interest to these college-age woman and helped me develop relationships with them. Additionally, they found it intriguing that I had left that job to work in this social services field.

One day, I received a phone call from Mervin. Before I had left the company, I had shared my plans with him.

He asked if I would present my work to the students at a college prep school in upscale North Atlanta. I can't remember his connection to the school now, but he believed in what I was

doing and wanted these kids to hear about it. It turned out to be a fruitful evening. Who would have guessed the connection?

In my research for this book, I came across a coded list of clients I worked with over one four-month period. Dozens and dozens of young women were represented on that list, which included notes beside the cryptic initials as to what the outcome of their situation was. Yes, I'd written abortion by some of the names, but a surprising number had chosen to parent or make an adoption plan despite the difficulty involved in these choices.

I worked trying to obtain housing or connect them to government services. A volunteer or I would go with them to tell their parents or boyfriends, take them to appointments.

While working for Franklin's, I had coordinated fashion shows and other kinds of in-store events. That background was of great value working for a nonprofit, because in addition to working with the women, we were always planning our next fund-raising event. No fashion shows, but I did learn how to put a golf tournament together. Same principles. Different clothes.

A few years ago, after a church meeting, I walked into the house and turned on the television to see a little of an international sports competition. I heard a familiar name called. I had to sit down on my sofa. That athlete's mother had been a young woman I had worked with to make an adoption plan.

I screamed so loud, my husband thought I was having some sort of episode.

I had changed the diaper of one destined to be an extraordinary athlete.

It reminded me of being in the airplane with a former president, but I didn't realize it until he emerged from first class. I had just done my job, spending time with this athletes' mother when she was pregnant, but sometimes, you just don't know whose company you're in. I never imagined that tiny baby nestled in the mother's womb would end up on a world stage.

I have many stories from directing the crisis pregnancy ministry. It was a rewarding time, but when I became pregnant with my first child, I knew I wanted to be a stay-at-home mom.

After two years in this ministry, I left and began the next blessed chapter of raising children. Interestingly, the board of the ministry I worked for asked if I would work it out for the ministry who handled our adoptions to take over the work we were doing. They did, and decades later they are still at it in our town making a huge difference in the lives of young women and their babies.

Guess who sent me a gift as soon as he heard I had Aaron, my first child? You're right. I received a gift from Mervin and then a phone call. I loved hearing his voice again. His continued connection in my life reinforced all that he had spoken over me.

My daughter, Bethany, was born eighteen months later, and when she was a couple of years old, I resumed the role of choir director and, later, worship leader that I had held in the years prior to having children.

In addition to this, I sang at civic events, women's events, church services, street ministries—anywhere anyone asked me to go.

In the church, I also led women's Bible studies, taught Sunday school, Vacation Bible School, and of course, helped plan women's events. When I chaired a luncheon for a group of several hundred clergy spouses in our denomination, I was thankful for my event training experience at Franklin's.

For almost a dozen years, I went monthly into women's prisons as part of a team who taught Bible studies and led worship in services. Oddly, my earlier years of dealing with a culture apathetic to Christianity translated into this new environment, but I also learned that in time, by our persistence and constancy, the women there began to trust the words we taught just as I had experienced in my time in the fashion world. We saw hundreds come to the Lord.

Later, I ministered in the favelas of Rio de Janiero alongside my daughter when she was a preteen.

I also traveled providing music in dozens of church events intended to bring renewal to the church.

All of this was leading to something else—what God had been speaking to me about for years, but I just didn't get it.

One day, my husband went into our closet, and one of the boxes of journals I had kept for years spilled onto the floor, "What are you going to do with all of these things?" he asked pushing them aside with his foot, so he could get to his clothes.

What was I going to do with them? A friend once asked me why I felt I had to write every day. I didn't know. I had done it since I was eight years old. It was like eating and sleeping for me—something I had to do.

Journaling had been therapeutic, consoling, a way of declaring the truth, worshipful—but in addition to these things, without even realizing it, it paved the path for me to actually become a writer.

I had seen myself in the singer/songwriter role and experienced joy in expressing God's Word through the lyrics I wrote. I'd even recorded two projects composed of songs I'd written.

What might be obvious to anyone reading this was a slow realization for me. I finally started to understand God wanted me to do something more with my writing than fill up journals and put them in cardboard boxes. Up to that point, no one but my college professors had read my essays. There may have been a letter to the editor here or an article for an in-house store publication there, but largely it had been mostly journaling and song writing.

In the late nineties, I sensed a shifting of sorts, a yet indefinable unrest. I had dreams at night where I saw myself moving into a new place, and as time went on, I realized that area was writing. When I sat down to connect the dots of what had at first seemed unrelated, spoken encouragements from people throughout my

life, I realized, too, that when connected, these dots all pointed to one thing—God was calling me to a writing career.

One of the more remarkable dots was again tied to those ten years in the fashion industry. I was asked several years after I left to come back and speak at the retirement dinner of one of my former bosses. I worked hard on what I would say. Shortly after I arrived at the event with many former colleagues and superiors in attendance, I realized those who came before me spoke more off the cuff. Had I over prepared? It was too late to change direction at that point. I was the last person to speak before my boss's daughter who would conclude the evening. I stuck to reading from my already prepared script and was surprised at the reactions of both laughter and tears.

Later, a woman I didn't know came up to me and said, "You should do this for a living."

I thought it an odd remark. How could you speak at retirement dinners for a living? Much later, I realized she was commenting on my writing. My boss's sister approached me and thanked me for my words. Then she hovered a bit, hesitant. "Was there something else?" I asked. "I want your notes," she said. I handed them over, scribbles and all.

Then tragedy struck. Sadly, I lost a friend to suicide. The events of that day were both tragic and traumatic, and that trauma connected with one from my childhood. I suffered from post-traumatic stress for several years. From this hard challenge, I came to write a series of forty devotions connected to acts of kindness done for me during this struggle. It was the first time I shared my writing for anyone else to read.

Also, I briefly corresponded with Jan Karon, author of the Mitford series. An encouraging note she wrote to me is framed and hangs in my office to this day. Her words also served as confirmation to the writing calling I was already beginning to feel in my heart.

Another big signpost occurred at a Christian family camp high in the Montana mountains where my husband was speaking. Again, someone I had never met came up and proclaimed almost prophetically, "Do it afraid." The fear of stepping onto a larger stage and falling flat on my face was huge. I thought maybe I'd stop feeling afraid and could more easily take the plunge, but I knew because of this admonition that I had to do it no matter how I felt. Reminded me of getting in all those New York elevators. If you want to move higher, you have to face your fears. Standing on a Montana mountain, I knew I had to move ahead with writing.

Then the event that really changed everything occurred. It all seemed so random at the time. I had to pick up Bible study materials in the Atlanta area, and the store that had them just a week before had sold out. I was then forced to drive almost into the downtown Atlanta area to another store. Frustrated due to the day's time constraints and in a big hurry, I literally ran in the store to get the materials. I paid, and then when I went through the exit door, out of the corner of my eye, I saw a brochure on the counter. I left the store, but then turned around and came back in. I picked up the leaflet about the Blue Ridge Mountain Christian Writer's Conference and took it home with me.

Over the next few weeks, that brochure laid on my desk, then early one morning I knew I had to go. I registered, sent in a few things to their unpublished writer's contest and won several awards. When the organizer of the conference, retired recently, I told her that every good thing that has happened to me in writing happened because of that conference.

Because of it, I began writing for a national and an international publication, which is distributed to millions around the world. The international publication is *The Upper Room* magazine, which I always had with me during those years I traveled in the fashion industry. I also started writing fiction because of an award I won at Blue Ridge. It's there I met Dr. Ted Baehr,

president of the Christian Film and Television Association, who encouraged me to write screenplays.

Today, I have two novels in print; one of them has won several awards. I have another under contract now. I've written six screenplays, one of them a Kairos Prize finalist and under option for a film. I have to wonder if watching all those Broadway plays helped me understand three-act structure, which is so key to writing screenplays. Those people-watching skills I honed while doing things like riding the Crescent gave me a host of characters to draw from while writing fiction.

Amazingly, I have also had the opportunity to meet authors who inspired me during those early years with my walk with Him. The book, *The Hiding Place*, by Elizabeth Sherrill that I almost gave back to my friend Jane because of Corrie ten Boom's inscription in it—well, I had an opportunity to spend time with Elizabeth while she was at a conference in a nearby city. She is just one of many who has been such an encouragement in my writing life.

I also started a blog, *One Ringing Bell*, which currently has over 700 posts.

A couple of years ago, I moved from painting with watercolors, which I had done sporadically through the years, to using oils, which I hadn't done since college. The screenplay I have under option is with an independent filmmaker and the budget very limited, but the script references many specific paintings I imagined. The woman who was to do the paintings became ill, and I wondered what we would do, but then I sensed the Lord leading me in that direction. I had no idea whether I could or not, but I started. When an opportunity to submit to a juried show arose, I took the chance and submitted one of the paintings, which was chosen for an exhibit at a state university gallery. I would have never thought that I might one day be the one exhibiting when I visited all those galleries long ago.

A friend recently asked how I find the time to write books and to paint. It goes back to those years in the fashion industry. I spent much of my life then planning and setting goals for sales, inventory, etc. In the same way today, I set goals as to how many words I will write each day, how many paintings I would like to execute, how many devotions I will submit. All those years of being forced to stand back and look at the big picture help me now to keep planning, revising, and reworking what I believe God is calling me to do.

Again, I'm nobody famous, just trying to be faithful, but Mervin was right. God did have plans for me beyond my life in the fashion industry. When I sit down to write, the experiences and people I knew during those years I worked on Seventh Avenue inevitably find their way into my writing. Because of that rich well of experience, I don't have to reach far to find traits that will flesh out the personalities of the characters in my stories.

All God taught me during that time did not diminish but continues to provide a foundation for that which has come after—a lifetime of ministry.

Paul wrote to the Philippians, "He who began a good work in you will carry it on to completion until the day of Christ Jesus" (Philippians 1:6).

I'm certainly not finished yet, but I pray God is carrying on that good work in my life. I never intended to write this book as what might be called in the publishing industry a "sunset book," a book that wraps up my life. I have more stories and much more to say. So, I'm eager for yet another chapter of what God would do.

Friends (Not the Television Show, Either)

I entered the clergy spouses' luncheon, took my place at a table, and then put my purse in the seat beside me to hold it.

I scanned the crowd, and her eyes met mine in that way that only happens to old friends. We exchanged smiles and she slipped into the chair beside me.

"Hi Bren," I said as we hugged.

Among the hundred or so other clergy spouses around us, I doubted that anyone had a relationship story as amazing as Brenda and me.

I first met Brenda when neither of us had even dreamed of being where we are today. I was the misses sportswear buyer at Franklin's and she had just transferred to the store as the cosmetics buyer.

We shared an office, our desks not twenty feet apart.

She seemed to be a believer but not involved in a faith community, so I invited her to ours.

She plunged in, became a church musician, and held several other positions. But most of all, she was my friend.

We hung out at work, hung out at church, and we hung out at home.

After Jerry and I married, and I left the company, I still saw her at church. But about the time I had my first child, Brenda transferred to another city as a group buyer.

With me having a new baby, and Brenda having a new job, even though she was only seventy miles away, the opportunities

to see each other dwindled, and then, sadly, became only once or twice a year.

At her new church, she met Dan who worked for a package delivery company but also felt a call to the ministry.

Later, they married and I stood with her as she said her vows.

When Dan decided to follow that call to ministry, he faced a long road beginning with an undergraduate degree and then seminary, but Brenda who by this time had switched jobs and become a buyer with a national restaurant company encouraged him the whole way. I kept thinking his church appointments while he was a student would bring them geographically closer to us, but sadly, they did not.

By the time he was ordained, they were as far away as they could be and still be within the boundaries of our conference of churches.

But just recently, Brenda called me. "I couldn't wait to tell you," she said. "We're moving again." I waited for her to tell me where, and when she did, I almost cried. If we met halfway, I would only be twenty minutes from her.

"I can't believe it," I said. "I feel as if I'm getting a piece of my life back."

"Me too," she said.

Today, Brenda and I are clergy spouses in the same denomination, and I hope we'll be meeting often to share life. Who could have guessed that turn of events decades ago when we were calling out to each other from desks twenty feet apart and arguing about how my back stock was crowding her office space.

On my first trip ever to New York City, I waited for our group to gather. We decided to meet in the hotel dining room, because we were all so tired from traveling that we didn't want to venture out. I had heard about this legendary buyer in another store, who had established herself as one of the most profitable in our company, but I had never met her. A tall blonde woman entered

the restaurant and moved to our table. A colleague turned to me, "Beverly, please meet Carolyn."

I stood to my five-foot-nine height and realized she was even a bit taller than me, nearing six feet. It was so nice to have someone with me in the stratosphere. I shook her hand and realized right off by her professional manner, this woman was cordial but all business. I guess that's how she had gained her reputation. For the next few years, the word professional is how I would sum up our relationship, not friends but business associates.

When we worked in the market together, heads turned. I still have a mental image of us walking down Seventh Avenue towering above the crowd around us.

I'll never forget when she left the company to work for another retailer, I ran into her on Seventh Avenue. Because of our height, we could spot each other a block away.

After I left the company and she reinvented herself as a medical office manager, through twists and turns, ups and downs, our relationship grew past the place where we had only business to share.

Most of that growth took place around serious life events. She had a terrible cancer scare, and then I was diagnosed with breast cancer. She lost close family members and parents, and I lost my parents.

We took turns visiting each other's towns so we could stay in touch, and the emails regularly flew back and forth.

Because I am also an artist, recently, she has become one of my biggest cheerleaders in encouraging me to apply for an exhibit at a gallery in her town. I'm going to do it, just because of her sheer perseverance.

One of the greatest joys in my life is calling these two friends.

Together, we have navigated not only the crowds on Seventh Avenue, but prayed our way through some of the most serious heartaches and obstacles life can throw at us, and we are still together all of these decades later.

I don't have to start all over every time I meet Carolyn and Brenda because they know my history, and I am once more grateful for those years I spent in the fashion industry because I would have never known them otherwise. There are many who mean so much to me, my friend Denise, my assistant Margie, and others too many to list.

Having friends that span a lifetime is one of the most incredible gifts. These relationships are worth investing in to help them endure.

One much wiser than I wrote, "As iron sharpens iron, so one person sharpens another" (Proverbs 27:17). These people have helped me become who I am today, and I hope I have had a miniscule part in helping them become the amazing people they are.

The Things That Might Have Been

Somewhere around midway in my career with Franklin's, a group executive who had always been kind to me approached one afternoon at a corporate gathering in Charlotte, North Carolina. "I've set up a lunch meeting with the head of the New York office tomorrow at noon. I'd like you to be there."

I studied him a moment. I wondered if I had misheard. "You want ME to be there?" What did he have in mind?

"I want him to get to know you."

But why? I thought, but nodded and made a note of the restaurant. I thought it better to let things play out rather than ask a bunch of questions.

Then my anxiety escalated What purpose could there be for me to meet with these executives? I had met the man briefly who presided over the buying services in New York and heard him speak from afar in market overviews. I felt very much out of my league with Him. But then, what else was new?

A restless night followed.

When I arrived at the restaurant, I tried to calm my shaky hands but didn't seem to be too successful. Honestly, I don't remember anything about the lunch except that I ordered a roast beef sandwich. I am not kidding. No, I couldn't have ordered a chicken salad plate or a cobb salad—I had to order like a ranch hand as if I had spent the

morning roping cows or something. I don't know what came over me, and when it came, my dinner companions went, "Whoa."

Whoa, indeed, little doggies. I couldn't figure out a way to eat the humongous thing without digging into it like a backhoe, so instead I just picked at it. I suppose Jean had been right about my menu choices. Where was she when I needed her, anyway?

Even though I didn't know why I was there, I still wanted to make a good impression.

I attempted to overcome my poor ordering with some brilliant observation about the market. Absolutely nothing came to mind. When we concluded our meeting, I had no idea what had happened.

So, you can imagine my surprise when that same group executive approached me again later and inquired whether I might be interested in taking a position in New York.

Against all odds, I had evidently impressed the buying office head enough that he was willing to entertain me taking a position there.

Moving to New York, though a fantastic opportunity, would effectively alter everything I had come to love about my life—my home, my friends, and one very special relationship.

Jerry, often says when giving his own testimony that when you reach the top of the ladder of success, there's always another ladder to climb.

He had climbed that ladder as an attorney, and had lived the best of what this life has to offer, climbing ladder after ladder. But it all came tumbling down in importance when he lost one of his sweet daughters in an accident when she was eight years old.

The home on the right street, the Mercedes, and the social standing meant nothing in the face of that terrible tragedy. Perhaps after listening to him give that talk what seemed like a hundred times, I got the message myself. Yes, God could have used me anywhere if that's what He chose to do, but I didn't sense Him leading me to New York on a permanent basis.

In the end, I said no to that big city move. Maybe Jerry and I could have maintained a long-distance relationship. I don't know, but my sense about it is that my children are on the planet today, because I decided there were more important things to consider than whether I would reach the top of the ladder. My relationship with Jerry was more precious to me than any promotion could ever be.

The prophet Isaiah wrote, "Whether you turn to the right or to the left, your ears will hear a voice behind you, saying, 'This is the way; walk in it' " (Isaiah 30:21). That is the way it has been with me. I have never, not for one moment, regretted that decision. Who knows what might have been, but I believe with all my heart that God has led me to the place I am today, and I am content and grateful for what actually has been.

Return to Seventh Avenue

I had just put my seat in the upright position preparing for landing when the pilot came on, "Looks like we're going to be a little early reaching Newark today. I never thought I'd use the words early and Newark in the same sentence." I looked at my sister, Tammy, beside me, and we laughed along with the other passengers on the plane.

In all my trips to New York City, I'd never flown into Newark. Only LaGuardia. I was coming into the city from a completely different perspective, which maybe was an apt metaphor for the circumstances at the time.

A couple of years before this trip, my younger sister found herself facing several dilemmas. She'd had a successful career as an educator, having been up for state teacher of the year. She knew that rarely does anyone receive those kinds of accolades twice. It seemed at that point, her career might be winding down. Additionally, her only son headed for college.

She also struggled with lifelong weight issues—weight issues she could never seem to conquer. She remembers walking into her house one afternoon after school and praying, "Lord, I'm just trying to hold on to what I have." What she heard next stopped her in her tracks.

"What if I want to give you more?"

Incredibly humble, she's not the kind of person to walk around asking for more. But more is exactly what God wanted to give her.

Within a year, she began her weight loss journey.

About the same time, she was recognized a second time in her career as teacher of the year for her school and her system, which put her again in the running for state teacher of the year. Though she did not receive the state award, she felt honored to make it that far again.

After persevering for almost two years, her Weight Watchers leader asked her to submit her story about losing 130 pounds to their Inspiring Stories contest. Yes, you read that right. One hundred and thirty pounds. As Tammy says, "I lost a whole person."

Later, out of thousands of entries across the country, she and five other women were chosen.

Reporters from CNN and the *Atlanta Journal Constitution* called to interview her as well as many regional magazines and newspapers. Weight Watchers also posted an interview and video of her on their site.

Incredibly proud of her, I could not have imagined that in this scenario more for Tammy also meant more for me.

Weight Watchers offered an expense-paid trip for her and a companion to fly to New York for interviews and photo shoots so she could appear on the cover of their national magazine.

Since her husband would not be able to accompany her on the trip to New York because of work obligations, she asked me if I wanted to go.

I had not been to Manhattan since my days working as a buyer. Oh, I'd passed over and under. Over on several trips to Boston for ministry opportunities. Another time, while traveling with my husband and children, we pulled into Penn Station on a train we'd taken from Washington DC, also headed for Boston for ministry. I wanted to run up to Seventh Avenue for a minute while we waited to depart, but it freaked my little kids out too much. They were afraid Mama would be left behind, so to save their nerves, I stayed planted.

This would be my first real trip back to the city.

When we arrived on a clear September afternoon, we checked into a lovely hotel and found we were staying on the forty-second floor. Even after all these years, I was still claustrophobic and freaked out by heights. Some things never change. Just ask me sometime about what happened at the CN Tower in Toronto and the St. Louis Arch when we visited them in recent years.

Anyway, we headed for the express elevator, because after all, is there any other way to ascend such heights?

When we opened our hotel room door, the view astounded as much as the one I had that week I spent looking out over Central Park. This time we had a sweeping view of the city, which included the Hudson River.

Amazing.

When we attended a Broadway Show, I received one of my biggest shocks as we passed through Times Square. Seriously? There were bleachers to watch the activities in the square. When I was traveling to the city, the only time you'd feel safe watching what happened in Times Square was from the comfort of your sofa on the eleven o'clock news. I felt as if I were at a theme park, the place had changed so much. This would take getting used to.

While looking for a place to eat dinner before the show, we came on a restaurant that served a prix fixe menu. "What's that?" my sister asked frowning as she pointed to the menu board. I reached down into my ten years of experience traveling to the city, feeling proud of myself, and explained how they were offering several pre-set courses for a fixed price to accommodate theatergoers.

At Rockefeller Center, we saw a revival of *South Pacific*, and it reminded me of the many musicals I had seen while traveling to the city. I could have seen that show every night we were there. As always, one of my favorite parts was hearing the orchestra warm up.

The thing that has always astounded me about the city is how much square footage a company will use to build a flagship store

for their product. Across the street from our hotel stood a huge two-story store, which offered only one product—those little brightly colored candies that don't melt except when you eat them. The old businessperson in me wondered what their sales might be to justify a space like that at such a high rental price per square foot.

While my sister did all the things she needed to do with Weight Watchers, I took to the streets to explore my old haunts. Unfortunately, I had failed to take in the intervening couple of decades since my last visit.

Yes, you guessed it. I wore heels. Very similar to the ones I used to wear. Updated of course.

After a day of walking in them, my aching feet caused my pride to submit.

With some effort, I marched myself to the Macy's shoe department, and purchased two new pairs of flats. Barbie Doll feet gone.

And speaking of Macy's, they still had many of the clickety clack escalators. I had to believe they stored pieces of the old ones so they could cannibalize them to keep the remaining ones running. The sound of those escalators warmed my heart. For me, nothing says New York like them. As of this writing, even after a recent 400 million renovation, Macy's still kept the wooden escalators—a tribute to their many fans.[37]

The layout of the store had changed a bit, but that stunning first floor of cosmetics and accessories still said, "Biggest store in the world."

I headed over to Seventh Avenue, visited several of the buildings and studied the marquees to see how many of the vendor names still looked familiar. Gone were the elevator men, now replaced with automation—a process that began when I still worked in the city. But beyond that, many of the buildings seemed almost unchanged from that time.

I navigated over to Broadway and did the same.

If Franklin's still had a buying office in the city, I might have stopped in to say hello. But they had long since moved all buying to their corporate headquarters in the southeast. Over the years, as the grandchildren of the original founder grew older, it became apparent they were readying the company for sale. So, just recently, this mammoth privately held corporation was sold to another corporation and is no longer under family control. Sad, but perhaps necessary in the changing retail environment. The current owners have a strong history of success and I hope will have this same result moving forward with Franklin's.

Though many of the buildings I visited seemed unchanged, I noticed one marked difference—the way I felt about seeing these places again. Always, during those ten years I visited the garment district, there was a certain drive to achieve—an excitement about all I might discover. That drive, that excitement was gone. This was no longer my world, and what's more, I didn't want it to be.

When the time came for my sister and me to depart, I pivoted in the taxi as we left the city and looked back toward the skyline.

"What are you doing?" my sister asked.

"Just saying goodbye." We exchanged glances, and I think she might have guessed what ran through my mind. Who knew when or if I would ever return.

We may look back and view parts of our lives as detours, what we did on the way to someplace else. Again, I believe God builds these times into our lives to prepare us for the next part of our journey. I don't believe my time in the fashion district was a detour, at all—but instead, the exact place God had for me at the time. I am blessed by the many lessons, opportunities, and relationships which it gave me.

The book in your hands is a culmination of those experiences, and I hope it will help someone to see that no matter where you are, God wants to use you.

"Now to him who is able to do immeasurably more than all we ask or imagine, according to his power that is at work within us" (Ephesians 3:20).

Fashion Tips. . .or Not

You didn't think I would leave without giving you a few fashion tips, did you? I didn't shop for a living all those years for nothing. Now granted, these may be eighties fashion tips, but still, here are insights you've been waiting for (or not).

If you have unlimited resources, most of these tips are not for you. You can pretty much do what you want, but for the ones like me who are trying to stretch their wardrobe budget just as far as they can, I hope you find a few ideas that might be helpful.

Now I know why everyone in the city wore black all the time. All you had to do was walk down the street on a drizzly day in Manhattan and have a taxi hit a puddle beside you to understand quickly the practical aspect of a dark wardrobe. I once sat in a hotel lobby waiting for my group to gather so we could head to the airport. The weather outside—rainy and cold. I noticed a woman in a group near me who wore a winter white wool pantsuit. I laughed. I'd give her about ten minutes on the sidewalks before something grey and gross splashed on her. I didn't have to ask if she was from the South, I knew it. Even if you take a taxi, you still have to wait on the sidewalk to hail one. All these years later, I have almost two rods in my closet of nothing but black. Those years of traveling to the city forever shaped my fashion choices.

Speaking of black, if you don't have several black options for pants and skirts for each season of the year in your wardrobe, then you have some work to do. I think, generally, as we've become a more urban culture, folks have moved toward this, but those dark separates make life a lot easier when you're getting

dressed in the morning. I had a buyer friend who owned about two dozen black skirts of various styles and fabrics. She had lovely blouses and sweaters she put with them. She wore one of those black skirts every single day and was one of the most elegantly dressed women I know.

Let's talk about accessories. I have decades-old silk scarves that my daughter and I still wear. Scarves are like pieces of art, they never go out of style. They don't have to be 100 percent silk, but they do need to have cotton, silk, or wool as part of the blend, otherwise they won't drape as they need to. Same thing with men's ties. A polyester tie always has a huge knot in it and hangs like a placard.

Be careful of red pants. Think fire engine. Enough said.

Invest in pieces that will last. I read that Katherine Hepburn wore the same wool pants for thirty years. I have pieces almost that old. It's worth it to invest in garments that are finely constructed and made of quality fabrics, especially if you are working in a business setting.

The fabric is the thing no matter which element of your wardrobe you're dealing with. I can still walk into T.J. Maxx, run my hand over the top of the hangers, and pull out an item that's interesting to me because of the fabric. Again, try to choose fabrics that have a 100 percent natural component of silk, wool, cotton, or at least a blend, which is dominated by one of these three. Today, also, because of sustainability, fabrics from bamboo have become viable alternatives.

The best price is not always the best price. Before you buy a garment off the 70 percent off rack, ask yourself if you would even consider it at full price. Is it a blouse you saw and then checked the price, or did you only consider it because that big clearance sign grabbed you? If it's the latter, be careful. Sometimes neat things do make it to those last markdowns. However, if you wouldn't give it a second glance otherwise, don't waste your money. You'll always feel weird in it, and then after it has

hung in your closet a couple of years, you'll give it away. Save yourself the trouble. Move on.

With the exception of a mother of the bride dress, try not to buy clothes just for special occasions. That has always turned out to be a mistake for me. If I buy a garment for a specific event, I usually don't have time to find what I want and settle for something that's just okay. If I buy things when I see them, there's always an option in my closet for any special occasion that might arise. Special occasion items can usually be purchased on clearance in the off-season. While I'm talking about occasions, don't wear your favorite black dress to a funeral. You'll always associate it with sadness. I have a few pieces I wear just to funerals and save the others for happy times. Of course, I have to remember that others probably don't attend as may funerals as I do as a pastor's wife.

This next tip is not going to sit well with some, but I'm going to say it anyway. If you're in a business environment, be careful with the prints. There's an unspoken perception that a print is less serious. Use your scarves to get out your print obsession and stick with mostly solids. You can always load up on the prints on the weekend.

About shoes, I believe in buying the best you can afford. I have often joked that I think there's a conspiracy out there, and those countries where we're outsourcing are out to get us through our feet. The shoes with the hard-plastic bottom on them—avoid at all costs. They will make your feet feel as my son once described his soccer shoes, which also had a hard-plastic bottom: "I feel like every bone in my feet is breaking," he complained. We tried to get by with a less expensive shoe but were quick to realize we'd have to invest in a leather upper and a more supple sole.

Good shoes usually do have leather uppers. I don't have a choice because all man-made materials except fabric cause my feet to swim in perspiration. The man-made materials today look

good in the stores, and though some are durable, a scuff sometimes is permanent.

I received a call one day while I was back in the store asking if I would come to a sportswear dressing room. When I arrived, the sales associate blurted out, "She's stuck."

"Who's stuck?" I asked, "And in what?"

Turned out one of our customers had tried on a skirt and could not get out of it. Oh, how I dreaded going into the dressing room. If it was a large-size customer, I needed words to say so she wouldn't feel bad about herself. Turns out, it was a woman who maybe wore a size zero. Thank the Lord. I kneeled down on the floor and began tugging at the zipper. They were right. It was stuck. We wound up cutting her out of the skirt. We had a good laugh about the incident, and introduced ourselves after it was over. Though I didn't know the woman at the time, we wound up having mutual friends and are still in contact today. Never try on anything unless you make sure the zipper works first.

The last bit of fashion advice comes from a man who made tents for a living. "Dress yourself in Christ, and be up and about" (Romans 13:14 MSG). If you haven't heard anything else in these feeble writings, please hear this good word from the apostle Paul. Nothing else matters if you do not know the one who gave His life that you might live eternally.

So there, and if we happen to run into each other in the grocery store, I might be wearing walking shoes, yoga pants and a half-zip pullover.

Don't judge.

About the Author

Southern writer, Beverly Varnado, writes to give readers hope in the redemptive purposes of God. She has two novels in print, *Give My Love to the Chestnut Trees* and *Home to Currahee*. Among several periodicals that have carried articles about her, *Southern Distinctions Magazine* highlighted her in an editorial of Georgia Authors, and *World Radio* featured her work as a result of a blog series she did on her family's 7,000 mile summer road trip.

She has won numerous awards for her work, including being a finalist for the prestigious Kairos Prize in Screenwriting, a finalist in screenwriting at the Gideon Media Arts Conference, a semifinalist in Christian Writer's Guild Operation First Novel. She currently has a screenplay under option with Elevating Entertainment.

Her nonfiction has appeared regularly in *The Upper Room* magazine, as well as *ChristianDevotions.US* and a Focus on the Family publication. Her work appears in several anthologies, *Faith and Finance*; *Short and Sweet: Small Words for Big Thoughts*; *Short and Sweet II*; and *Merry Christmas Moments*.

She has over 700 posts on her blog at *One Ringing Bell* (http://bev-oneringingbell.blogspot.com) where you will find "peals of words on faith, living, writing, and art." She has also been writer and editor at *One Old Dawg: mostly true Bulldog lore*, which chronicles her husband's football experiences playing on legendary Coach Vince Dooley's teams at the University of Georgia.

She graduated cum laude with a degree in art, and works as an artist, most recently exhibiting in a state university gallery.

Her volunteer efforts include: twelve years teaching and leading worship in maximum security prisons for women, University of Georgia Wesley Foundation board member, and vocalist in the Athens Symphony Chorus.

She lives in North Georgia with her husband, Jerry, and their chocolate Aussiedor, Lucy, who is outnumbered by several cats. She is the mother of two recent college graduates, Aaron and Bethany, as well as daughter, Dr. Mari Varnado Smith and the two best grandchildren ever, Walker and Sara Alden.

Endnotes

1. "Designing Women Episode Guide," IMDB, http://www.imdb.com/title/tt0090418/.

2. "Wedding Dress of Lady Diana Spencer," *Wikipedia*, https://en.wikipedia.org/wiki/Wedding_dress_of_Lady_Diana_Spencer.

3. Danica Lo, "Did You Know Jackie Kenney Is the Reason Those Iconic Jack Roger Sandals Exist?" *Glamour Fashion*, December 2, 2014, http://www.glamour.com/story/did-you-know-jackie-kennedy-is.

4. "It All Started with a Juice Stand," *Lily Pulitzer*, https://www.lillypulitzer.com/custserv/custserv.jsp?pageName=OurStory.

5. Elizabeth Murray, "Nancy Reagan's Fashion Influence: A Look at Her 'Simple and Elegant Style,' " *Today*, March 6, 2016, http://www.today.com/style/nancy-reagan-s-fashion-influence-look-her-simple-elegant-style-t78141

6. http://www.marydemuth.com/

7. Robert Frost, "The Road Not Taken," *Poets.Org*, https://www.poets.org/poetsorg/poem/road-not-taken.

8. Charles Stanley, "Forgiveness and Consequences," *In Touch Ministries*, January 16, 2015, https://www.intouch.org/read/forgiveness-and-consequences.

9. "Kristl Evans: Miss Georgia 1981," *After the Crown*, April 6, 2014, http://www.afterthecrown.com/blog/2014/04/06/kristl-evans-miss-georgia-1981/.

10. Charles Stanley, "Forgiveness and Consequences," *In Touch Ministries*, January 16, 2015, https://www.intouch.org/read/forgiveness-and-consequences.

11. Jay Clarke, "New York's famed Waldorf-Astoria hotel celebrates 100th anniversary," *Knight Ridder/ Tribune News Service*, October 11, 1993, https://www.highbeam.com/doc/1G1-14226427.html.

12. "Waldorf-Astoria," *Wikipedia*, https://en.wikipedia.org/wiki/Waldorf_Astoria_New_York

13. "Hotel Pennsylvania," *Wikipedia*, https://en.wikipedia.org/wiki/Hotel_Pennsylvania.

14. Ibid.

15. Ibid.

16. Mary A. Baker, "Master, the Tempest Is Raging," http://library.timelesstruths.org/music/Master_the_Tempest_Is_Raging/.

17. Emily Freedom, *A Million Little Ways*, (Grand Rapids, Michigan: Revell Publishing Group, 2013), 14.

18. About McNair Wilson: http://www.mcnairwilson.com/.

19. "Pascual Pérez, *Wikipedia*, https://en.wikipedia.org/wiki/ Pascual_P%C3%A9rez.

20. Richard Sandomir, "A Pitcher Recalled for his Broad Spectrum of Quirks," *New York Times*, November 2, 2012, http://www.nytimes.com/2012/11/03/sports/baseball/pitcher-pascual-perez-was-known-for-his-quirks.html.

21. "Selfridges," *Wikipedia*, https://en.wikipedia.org/wiki/ Selfridges.

22. David W. Dunlap, "Latest Miracle on 34th Street: Macy's Keeps the Wooden Escalators," *New York Times*, November 25, 2015, https://www.nytimes.com/2015/11/26/ nyregion/macys-historic-wooden-escalators-survive-renovation.html?_r=0.

23. "Silver Bells," *Wikipedia*, https://en.wikipedia.org/wiki/ Silver_Bells.

24. Ibid.

25. Celestine Sibley, *Turned Funny*, (New York: Harper & Row Publishers, 1988), 187.

26. "Crescent (train)," *Wikipedia*, https://en.wikipedia.org/ wiki/Crescent._(train)

27. About J.B. Phillips: https://jbphillips.org/.

28. Dietrich Bonhoeffer, *The Cost of Discipleship*, (New York: Simon and Schuster Inc., 1959 SCM Press Limited).43

29. "Sozo," NAS New Testament Greek Lexicon, http://www. biblestudytools.com/lexicons/greek/nas/sozo.html.

30. "Lindy's," *Wikipedia*, https://en.wikipedia.org/wiki/ Lindy%27s.

31. Ibid.

32. Mama Leone's menu, private collection.

33. Howard Kissel, "At Asti, the Fat Lady is Singing," Daily News, December 30, 1999, http://www.nydailynews. com/archives/nydn-features/asti-fat-lady-singing-curtain-falling-restaurant-opera-menu-75-yrs-article-1.855729.

34. "About the Russian Tea Room," *Russian Tea Room*, http:// www.russiantearoomnyc.com/about-us/.

35. Oswald Chambers, *My Utmost for His Highest*, edited by James Reimann, (Grand Rapids, Michigan: Discovery House Publishers, 1992 by Oswald Chambers Publications Assn.) May 25 devotion

36. Ibid, May 8 devotion.

37. Dunlap, https://www.nytimes.com/2015/11/26/nyregion/ macys-historic-wooden-escalators-survive-renovation. html?_r=0.